IMAGES OF ASIA

At the South-East Asian Table

Titles in the series

At the
South-East Asian Table

ALICE YEN HO

KUALA LUMPUR
OXFORD UNIVERSITY PRESS
OXFORD SINGAPORE NEW YORK
1995

Oxford University Press

Oxford New York
Athens Auckland Bangkok Bombay
Calcutta Cape Town Dar es Salaam Delhi
Florence Hong Kong Istanbul Karachi
Madras Madrid Melbourne Mexico City
Nairobi Paris Shah Alam Singapore
Taipei Tokyo Toronto

and associated companies in
Berlin Ibadan

Oxford is a trade mark of Oxford University Press

Published in the United States
by Oxford University Press, New York

British Library Cataloguing in Publication Data
Data available

Library of Congress Cataloging-in-Publication Data
Ho, Alice Yen, 1948–
At the South-East Asian table/Alice Yen Ho.
p. cm.—(Images of Asia)
Includes bibliographical references and index.
ISBN 967 65 3107 3:
1. Cookery, Southeast Asian. 2. Food habits—Asia, Southeastern.
3. Asia, Southeastern—Social life and customs. I. Title.
II. Series.
TX724.5.S68H63 1995
394.1'0959—dc20
95–9419
CIP

Typeset by Indah Photosetting Centre Sdn. Bhd., Malaysia
Printed by Kyodo Printing Co. (S) Pte. Ltd., Singapore
Published by the South-East Asian Publishing Unit,
a division of Penerbit Fajar Bakti Sdn. Bhd.,
under licence from Oxford University Press,
4 Jalan U1/15, Seksyen U1, 40000 Shah Alam,
Selangor Darul Ehsan, Malaysia

To my husband James,
and my brothers Choon and Leong,
for sharing my interest in
things traditional

Preface

IN most cultures, the daily meal is a mundane affair. In South-East Asian homes, its preparation is relegated to the kitchen behind the house where visitors are not expected. Yet, food, as a daily affair or as a religious thanks offering, is a source of utmost enjoyment to the peoples of South-East Asia. This passion for food is reinforced by incessant discussions of the ways and means of turning the simplest ingredients into the tastiest and most economical of meals. Sacrifices to generous gods and good spirits are brimful of gratitude, rejoicing, and humour.

I grew up in the oil town of Miri, Sarawak, in an interesting community in the 1950s and 1960s. An Arab textile business family lived a few shophouses away from us. They spoke flawless Hakka, and shared their stoves and cooking styles with their Chinese neighbour; only one ate no pork and the other, no mutton. Not far away was an Indian spice vendor whose kitchen was famous for its redolence. I was sometimes sent over to get curry pastes that had come fresh off the mill. I often came away with tips on how to Indianize our Chinese curries, such as by adding some mustard seeds to the fish curry to obtain that inimitable Indian zest. The Eurasian and colonial residents, and in the post-colonial period, expatriates in oil businesses, stimulated the local interest in bakery, and cold storages were established commercial concerns.

My mother, who was a Chinese herbal doctor, often sent me on errands to pick up herbal prescriptions and deliver them to her special Nonya and Indonesian patients in their housing estates or government bungalows. I quickly took to the lively households of adults spontaneously singing and dancing to the radio. Music of another kind, from the mortar and pestle, was played in the constantly busy kitchen where I was at liberty to take in the aromas and to pick up a love for meddling with food. The market-place was also my early 'school', especially on Chinese festival days,

when I had to help with the buying and carrying, though not the cooking.

When I was fifteen, I was treated to a simple *slamatan* (a kind of 'thank you' meal) at my Malay classmate's kampong house for administering to her some Chinese medicine when she fell ill at school. Two of the chickens scratching and pecking under the house while we were giggling upstairs were slaughtered by her father as he mumbled a prayer facing west. The main dish was a delicious kampong chicken curry. Another indigenous meal of which I have fond memories was that given by a Dayak girlfriend who treated me to jackfruit cooked in *belacan*, chillies, and palm sugar. These were a far cry from the Chinese herbal cooking and feast-day shark's fin delicacies of my parents' kitchen. But in our ordinary meals, we sometimes spiced up our food with dried prawns, chillies, *belacan*, salted fish, and freshly fermented fish. *Rojak*, *ice kacang*, and *satay* as snacks added variety to our Chinese meals of lotus root soup, braised sea cucumber, and other exotic dishes.

Among the many gourmets that I met during my career in the 1970s was a Dutch lady who ate every local or European meal with a spoonful of Indonesian *sambal terasi* (shrimp paste pounded with chillies) from a litre-sized jar in her fridge. Living overseas, first in England and then in North America in the 1980s, I developed a craving for the colourful and savoury cooking of Malaysia. To find galangal and *serai* powder imported from Indonesia was cause for ecstatic celebration. I began to appreciate the need of South-East Asian urban workers to make pilgrimages home to their villages—*balik kampung*—whenever the opportunity arose on feast days or holidays, for, like me, they must have missed the unadulterated goodness of home cooking.

My interest in food cultures was shared with a friendly Filipino couple in Canada, Lorenzo and Norma Reyes, in whose home I ate many dinners. The major topic of our conversations deep into the night was food, its many hows and whys, and dos and don'ts back home in the Philippines or Malaysia. I first learnt of the Filipino love for sour food from the Reyes, who, being typical South-East Asians, were constrained to force their hearty country fare on me. Thanks to them, the idea was born that I should tran-

scribe some of these observations into writing one day. Only, it was a vague idea that had much growing to do.

At the South-East Asian Table is the culmination of my quest into the sociological and historical aspects of the South-East Asian culinary cultures. In this book, I have tried to weave a pattern into the rich cultures of the region by threading together their many diversities and similarities in food throughout history. I have used various quotes from Western travellers and writers of the past four centuries to highlight the fact that not much has changed over time in the food habits of South-East Asia.

Besides the many friends who have made this an interesting subject to explore, there are many more who have encouraged me in the writing process. I would first like to thank Maya Jayapal for suggesting a publisher to me. To Maya again, Alison de Muth-Pearce, and Lise Young-Lai, I owe an unaccountable debt for that final push to put down on paper what had previously existed as intangible thoughts and ideas. Special thanks are due to Rosalind Tay, for allowing me to experience her delectable Burmese home cooking and for providing me with insights into her Burmese culture; Sue Sismondo, for editing my several food and culture articles; and Saralee Turner, for her comments on the Introduction.

I would also like to acknowledge the following individuals and organizations: Julie Yeo and the late Michael Sweet of Antiques of the Orient in Singapore, for their quick response to my request for illustrations; the Institute of Southeast Asian Studies, Singapore, for the use of its library; the staff of the Southeast Asia Room of the National Library of Singapore, from where more research materials came; and finally, the Friends of the National Museum of Singapore, whose many organizational activities on the cultures of Asia have enriched my sojourn in Singapore.

The kudos inevitably goes to my daughter Tricia, for a wonderful job in picking out the 'bugs' in my manuscript before its submission. And last but not least, a myriad thanks go to my husband, for his lifelong sponsorship of this hobby of a 'professional student'.

Singapore ALICE YEN HO
August 1995

Contents

1
Introduction

INSCRIBED on a stone pillar amongst the thirteenth-century Sukhothai ruins of Thailand is part of a royal declaration: 'In the water there is fish, in the fields there is rice.' The statement not only echoes the Thai synonym for their daily meals—'eat rice eat fish'—but reflects the general trait of simplicity amidst abundance in the South-East Asian daily fare. More than three-quarters of South-East Asia's population is agriculture-based, spread out in small towns and rustic kampongs. Rice, the most well-loved grain and staple, may be cultivated in wet or flooded rice fields, or in hill forests, where slash-and-burn cultivation is practised. Where flat lands are scarce, ancient irrigated rice terraces have been cut into higher elevations, looking like thousands of broad flights of stairs ascending into the clouds.

South-East Asia lies within the tropical zone, bordering on the subtropical in the northern mainland, and is blessed with mountains, lowlands, and great waterways. The South-west Monsoon brings heavy rainfall to the mainland countries of Thailand, Burma, Laos, Cambodia, and Vietnam from May to October; the dry North-east Monsoon blows from November to March. The interim period of intense heat preceding the deluge of rain makes the monsoons a pleasant cycle in the life of the mainland rice farmers. In the countries of the archipelago—Malaysia, Brunei, Indonesia, Singapore, and the Philippines—both monsoons bring copious year-round moisture. Constant high temperatures and humidity have given the whole equatorial region a rich vegetation that many Western travellers and botanists have lauded as the 'plenitude of nature'. In *Western Impressions of Nature and Landscape in Southeast Asia* (1984), Victor R. Savage notes that the abundance of 'crop, fruit, game, fish, and other food stuffs [has] intoxicated the native to a carefree and happy state' where he was 'at home with his environment' and his wants were 'easily satisfied' (Colour Plate 1).

Rivers, gorged with rain, meander from mountain ranges, bringing rich alluvial soil on to the plains, and yielding bounteous catches of fish all the way to the deltas and coastlines. Coastal and island dwellers enjoy a daily harvest of seafood, especially during the calmer weather after each monsoon. Inlanders net freshwater fish from rivers, rapids, ponds, streams, lakes, and flooded paddy fields (Plate 1). Fishing is not merely a necessary or supplementary occupation for the rice farmers but a pastime enjoyed by all with high spirits, especially when the monsoon rain swells up the waters. The fifteenth-century naval expedition of the Chinese admiral Cheng Ho recorded the amazing quantity of fish in the coastal markets of South-East Asia. Antonio Pigafetta, accompanying Ferdinand Magellan in 1521, in his *First Voyage around the World*, wrote repeatedly that they dined 'on rice and fish' during their sojourn in the Philippines. Rice, fish, fruits, and vegetables

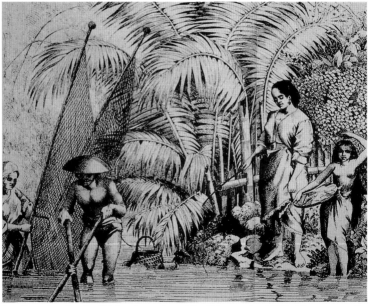

1. A native family fishing by a riverside; lithograph, 1877. (Courtesy of Ayala Museum Library)

are the mainstay of the region's daily meals.

Long before the Christian era, the Mons and Khmers of Burma, Siam, and Cambodia, the later Pyus, the Chams of South Vietnam, and the long-settled Malay peoples of the archipelago were highly skilled craftsmen and rice farmers, intrepid seafarers, and fishermen, whose lives were determined by the rhythm of the monsoons. They were proficient barterers, who by the early centuries were trading with the Indians and Chinese who utilized the monsoons to advantage along the coasts and the open seas. With this early Indian contact, they were to invite Indianization into their culture through Brahman high priests learned in Sanskrit text, philosophy, literature, arts, religion, and the structure of kingship. Existing alongside the strong native animism were Hindu cult worship and Mahayana Buddhism, whose visible remains are the imposing temples, *wat* (monasteries), and pagodas that dot the tropical landscapes. At the same time there were gradual migrations of Burman, Tai, Lao, and Shan peoples from Tibet and south-west China into the plains of the mainland, which quickened in the eighth–twelfth centuries as the Mongols advanced south and eastwards. These peoples brought with them Tibetan and Chinese Yunnan cultures, the cooking styles of which were to be augmented by the lushness of the tropical vegetation. In turn, these migrants intermingled with and were similarly Indianized together with the indigenous people.

As Buddhism reached the height of its glory in the tenth century, Islam arrived in Sumatra and Java with Indian Muslims and Arab traders. By the fourteenth century, it had supplanted Buddhism and Hinduism there (except in Bali), and was spreading to Malaya, Borneo and Brunei, and the southern Philippines. The people of northern Vietnam, who were closer to Chinese soil and subjected to Chinese rule from 111 BC to AD 939, were untouched by Hinduism. In the thirteenth century when all the mainland countries had fully converted to Theravada Buddhism, Vietnam was avidly modelling itself on China's social structure. Chinese Confucian and Taoist ethics and Chinese-style Mahayana Buddhism were fully assimilated into the Vietnamese culture by the seventeenth century as more southern Chinese pushed further south

into Vietnam. Equally unaffected by the Hindu influences were the region's millions of mountain and hinterland tribal peoples with their animistic cultures. Some of these were to embrace Christianity after the eighteenth century, like the Karens of Thailand and Burma, the Dayaks of Borneo, and the Bataks of northern Sumatra.

When the Europeans finally arrived in the sixteenth century in search of spices, the South-East Asian region had long been an important commercial hub of the Old World Maritime trade that not only supplied a variety of products to China but linked it with the Middle East and Europe. Water-borne bartering trade, international and regional, in what was known as the Lands under the Winds, reached its zenith during this period (Plate 2). Nutmeg, cloves, mace, aromatics, tin, and Chinese goods were exchanged for Indian and Middle Eastern piece-goods, textiles, other aromatics, and spices. Pepper, Western World imports, sappan wood, and many jungle products were exchanged for Chinese porcelain, silk, satin, tea, and metal goods.

With the Europeans came Christianity. Malacca, the seat of Islamic learning, fell to the Portuguese in 1511 while the Spanish took the northern Philippines in 1521. Over the following three centuries, the Dutch, British, French, and Americans came in quick succession, first as trading rivals and later as colonists. The nineteenth-century British colonial period in Malaya, Brunei, Singapore, and Burma, and the French era in Indo-China brought a new influx of Chinese from south China's coastal provinces, as well as Indians from southern India, as labourers, immigrants, and merchants. The dawn of the twentieth century saw a greater mixture of peoples and cultures in South-East Asia, particularly in the archipelago where the open seas had, from time immemorial, been the confluence of trade and migration. With their strong sense of family culture, the South-East Asians have been able to absorb eclectically all foreign influences without losing their pristine identity. Hindu influences were deeply entrenched in rites of worship and religious ceremonies, in the arts, in dance and literature, and in the code of daily life and conduct. Much was culled from Indian, Chinese, and Arab pharmacopia, while

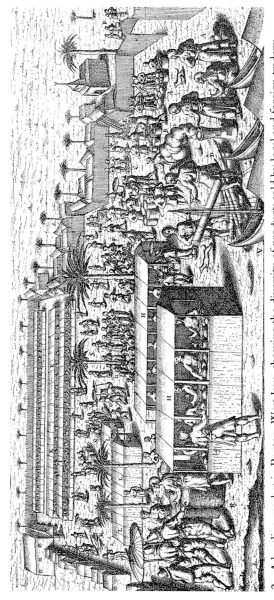

2. A bustling market in Banten, West Java, showing the diversity of products sold by local and foreign traders; engraving, Amsterdam, 1598.

European influences were mainly coastal and urban, involving money economics and modern industrialization.

In bestowing plentiful fish and vegetables on the South-East Asian table, the equatorial climate has not allowed for the open pastoral lands required for beef cattle rearing. Although meat is craved, and is eaten whenever it is affordable, meat consumption is governed by the numerous religions to some extent. Buddhism forbids killing, so Theravada Buddhists in the mainland, including monks, depend entirely on non-Buddhists for their meat supply. Those who wish for a better rebirth and monks during Lent and on holy days abstain from meat. Mahayana Buddhism proscribes beef eating. Its Chinese and Vietnamese believers abstain from all meat on holy days; and monks are strictly vegetarians. Islam forbids pork consumption, so Muslims are suppliers and consumers of chiefly beef and mutton. The Christians in the northern Philippines, and minorities elsewhere, have their meatless holy days, and all southern Indian populations are vegetarians. It is not surprising then, that besides its rich supply, fish, requiring no blood-letting, is the daily 'meat' or protein food for all. The pig, however, being the most economical domestic animal to breed, provides the cheapest meat that is daily available from Chinese butchers. Pork is the favourite of non-Muslims and Chinese everywhere. Chickens and ducks are liberally eaten wherever available, while game, venison, snails and frogs, and even insects (grasshoppers and cicadas) are savoured by many inland dwellers. In the indigenous daily meal, meat, particularly beef, is an expensive food that provides an occasional relief from the regular fish.

The chief source of beef is the water-buffalo, except where small-scale cross-breeding of cattle and buffalo or imports supply the demand. To the majority of the rural folk, buffaloes are draught horses in paddy fields and in transportation (Plate 3). Only the sick or old ones are given up, and the best are reserved for religious and festive sacrifices. Even as it becomes more easily available in many areas, it is eaten in small amounts, finely chopped or cut to enhance a vegetable or soup; never as a course by itself. Simple daily meals and elaborate feasts characterize all South-East Asian culinary cultures.

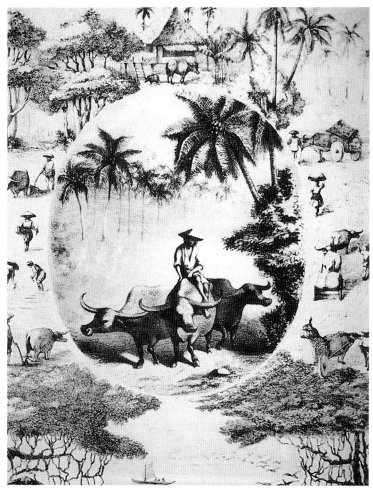

3. An agriculture-based South-East Asian rural scene showing buffaloes being used for ploughing as well as for transportation; lithograph, 1859. (Courtesy of Ayala Museum Library)

In the cycle of religious or secular festivals or fiestas throughout the calendar, the new year and harvest are the most important. In Thailand, the beginning of the rice-planting season is marked by an elaborate royal ploughing ceremony (Colour Plate 2). Then there are myriad rites of passage that are celebrated with food and offerings, such as the Javanese tooth filing ceremony and the mainland adolescents entering monkhood or tonsure ceremony. As J. F. Scheltema wrote in *Peeps at Many Lands: Java* (1926): 'Indeed, every excuse is welcomed for a *sedakah* or *slamatan* to please the invisible powers who, they imagine, derive an enormous amount of satisfaction from the spiritual part of the repasts. . . .' The Bataks of Sumatra are known to slaughter more than two hundred buffaloes for the funeral gathering of an important personage. In some Cambodian, Laotian, or Indonesian villages, communities sometimes share the cost of slaughtering and dividing a buffalo, and invent an occasion to satiate an appetite for beef, or even just to dispose of an old 'work horse'.

Much of South-East Asian cuisine is said to be born of festive meals cooked with the participating spirit of *gotong royong*, or 'communal assistance'. In agricultural life, neighbours help each other in planting and harvesting rice, hauling in fish, mending the roof, putting up a fence, and building bridges. Such gratuitous work is repaid by a feast, during which the ordinary, affordable, and much-revered vegetables play no role. Meat dishes, particularly beef and chicken, in rich curries or stews, are ritual food that cram the festive table in honour of both men and spirits.

To the religious South-East Asians, food, being the gods' gift, nurtures both physical and spiritual well-being. Thanksgiving offerings and sharing of food with deities and creatures are festive as well as daily affairs, as Bali's Hindu culture demonstrates. Metre-high *bebenten* of decorative and awe-inspiring presentations of fruit, vegetables, rice, and rice cakes are offered at the temples on holy days by throngs of devotees. Complete miniature meals—rice, salt, flowers, and betel quid—contained in woven leaves are served to gods and spirits before human beings tuck in. Whether in a rural Thai home or a Dayak longhouse in Borneo, a little food before dinner is offered to the gods on high altars or rafters, and to little

creatures like birds and ants in the backyards. Theravada Buddhists would donate food to the monks on their early morning rounds as monks eat only once before their noon hour of eleven (Colour Plate 3). In Java, a drop of beverage is casually splashed on the ground to appease any thirsty spirits around. In Cambodian terms, food is no longer ordinary when blessed in the *wat* by the monks, or shared with the deities and ancestors' spirits at home.

A casual verbal invitation to passers-by to join in a meal in progress, or inviting new acquaintances home for dinner, is a common gesture of courtesy among all the people. There is no counting of mouths to feed in a dinner or feast. The Laotians say that it is their practice 'to prepare more food than will be consumed'. In *The History of Java*, Thomas Stamford Raffles remarked in 1817 that 'in no country are the rights of hospitality more strictly enjoined by custom and practice'. Placing good food before the guest is not enough. One 'should render the meal palatable by kind words and treatment, to soothe him after his journey, and to make his heart glad while he partakes of the refreshment'. Raffles concluded: 'This is called *bojo kromo*, or real hospitality.' It is to be noted that not only were Antonio Pigafetta and his fellow explorers well fêted by the Filipino chiefs (Colour Plate 4), but when they reached Brunei, they were treated to a sumptuous feast by the 'governor's men' with '30 or 32 different kinds of meat', including peacock, besides all kinds of fish.

What sociologists call the 'southern warmth' of the South-East Asian personality is highly exemplified by a legendary tale of King Chulalongkorn (Rama V, 1868–1910). One of Thailand's favourite monarchs, he is said to have often gone for a taste of the common life. Once, as the royal boat cruised incognito down the river, he was heartily hailed by an onion planter and his family and invited to join in their 'coarse rice and fish'. The king and his courtiers graciously accepted and sat down to partake of 'rice in a blackened pot; on coconut shell dishes, fried lettuce, salt fish and chillie sauce' (Barrett, 1971). Only after dinner did the family recognize His Majesty's regal countenance and manners, and realize that, in their splendid simplicity, they had dined with the king.

2
Regional Styles

THE South-East Asian folk meals are simple yet robust, economical yet fresh and richly flavoured, and full of peasant charm and native spiritualism. The vast region is populated by diverse peoples, sharing borders and waterways in many areas, and tolerating many differences in beliefs, customs, and languages. Thus very similar food ingredients are used throughout but in various styles and with different flavours. An example is curry, which differs characteristically with the slightest change in local emphasis on, or preference for, certain spice mixtures and basic ingredients. It also varies within the country, depending on areas and border contact. For example, in the north-western area of Burma, closer to the Indian continent, curry has a substantial Indian spice content, and yogurt and milk are more liberally used. North-eastwards, milder curries with Chinese spices dominate and towards the east and south, a Thai and coastal Malay style prevails. In the Thai and Malaysian border area, an interesting mix of rich Thai and Malaysian cooking remains from the days of the Thai reign over the four northern states of the Malay Peninsula.

While Indian spices and their blending skills are part and parcel of all curry dishes, Chinese food ingredients and cooking methods are infused into the whole region's basic meals. Chinese noodles, enhanced by local flavour, are eaten not only for breakfast and lunch but also as a savoury snack. Chinese soya bean products like soya sauces, salted soya beans, bean curds, and Chinese spices are fully and cleverly indigenized. Despite the ever-present Chinese tendency to cook everything, however, much food is eaten raw, like salad, fish, and meat. 'Fish sour' or 'prawn sour' is eaten almost all over the whole region. Pounded fish meat is packed in banana leaves with boiled rice and salt, and 'ripened' before being served with lemon grass, chilli, onion, garlic, and lime juice.

The Countries of the Mainland

Before the nineteenth century, with waves of migrations and trading caravans traipsing across the land mass, amidst the rise and fall of rival empires, mainlanders had few political boundaries. The sharing of similar soil demarcated by modern borders meant the borrowing and mixing of centuries of ideas. Fish sauce is commonly used for dips and all indigenous-style cooking. Steamboat-style cooking—raw food quickly dipped in hot stock and eaten with sauces—from Mongolian roots up north is common to all inhabitants of the mainland, especially during the cool monsoon months. Three-layered pork, braised or roasted, is one of the favourite dishes in general, while most food is cooked by quick blanching or stir-frying and steaming.

Burmese home cooking is backed by a keen knowledge of the goodness of herbs and vegetables. Food is ingested with a concentrate of bewildering flavours and textures: crispy, fragrant, red-chilli hot, bitter, saltish, sour, sweet, aromatic, and perhaps more, savoured almost all at once. An example is the *balachang*, the Burmese counterpart of the Malaysian *sambal udang kering*. A pungent condiment that accompanies every meal, this is composed of dried prawns, chillies, shrimp paste, turmeric, and sliced garlic stirred in hot oil. Roasted chick-peas, noodle bits, finely pounded dried prawns, crisply fried garlic and onion, and fresh herbs garnish every dish. Ingredients are meticulously cut and cooked in wholesome sesame and peanut oils, with spices, sugar-cane, and vinegar as natural preservatives.

Thai flavour is pronounced in the tangy lemon grass and the fiery tiny chillies, *prik*, cutting into a sour-sweet tamarind and lime base or sweet coconut milk. Emphasis placed on groups of fresh herbs, roots, chillies, and spices produces spectacular blends of 'colour-co-ordinated' Thai curries. With their propensity for gilding everything, the Thais have lent their aesthetic touch to food and utensils, and Thai expertise in fruit carving is renowned (see Chapter 6). Thai sweets (like others throughout the region) are based largely on rice flour, palm sugar, and coconut. They have a colourful history in the hands of a seventeenth-century Portuguese

11

adviser's wife in the Thai court, and in the eighteenth century, in the romantic and poetic court history of the queen mother of King Mongkut (Rama IV, 1851–68). Royal interest in agricultural skills to ensure abundant good food and the regular presentation of impressive banquets to foreign diplomats have developed Thai cuisine into an art. King Chulalongkorn is said to have been a food connoisseur who often experimented with recipes in his palace kitchen. Such refined culinary standards demand hours of laborious preparation but quick fresh cooking. The business-minded Thais had by the early nineteenth century supplied housewives with well-prepared pastes and cut ingredients in the market.

The Khmer empire, centred in Angkor Wat, boasted a sophisticated rice cultivation that reaped three crops a year before the fifteenth century, when it fell to the Thais. Scenes of its ancient bustling economic life are permanently etched by its artists into the beautiful monuments of the Bayon, which hold in frieze its past glory. Cambodia emerged in 1887 as part of French Indo-China with Laos and Vietnam until 1954. Thai, Chinese, coastal Malay, and southern Vietnamese flavours are all present here. French influence is seen in the urban cuisines of all three former French colonies, in such foods as French bread eaten with local roast pork or beef stew, patisserie, pâté, onion soup, and *café au lait*. Home cooking is very much marked by the use of a relish known to all mainlanders—the powerfully odorous fermented fish. Known as *prahok* in Cambodia and *padek* in Laos, freshwater or seawater fish are salted, sun-dried, pounded, and packed with toasted rice and rice husk. Clay or stone jars of these sit for a month or two on the veranda of the house, innocently emanating a notorious aroma. (The Philippines' *bagoong* and Malaysia's *cincalok* are similar products.) The sauce and fish are used together or separately to flavour everything raw or cooked. The meat, pounded with ginger, fresh mint, and pepper, is made into *padek khouang*, which like the pounded *sambal belacan* of the Malay meal, is an indispensable Cambodian or Laotian condiment.

A basic Laotian cooking skill is the fine chopping and pounding of any meat, or fish, into a smooth paste. This is eaten raw, rare, or well cooked, with chilli, fried garlic and onion, ginger, lemon

grass, Kaffir lime leaves, fresh herbs, *padek khouang*, and hot broth. Called *lap*, meaning 'auspicious' in Laotian, it is a traditional festive food. Raw *lap* is deemed to be men's 'party food', downed with much wine or beer, inviting Western comparisons with the tartare steak. The Laotians prefer the sticky, glutinous rice or *khao neo* (which has to be soaked before cooking) to the ordinary loose-grain, fluffy rice. Served from beautifully woven rice baskets, the rice is rolled in one hand, and, with a pinch of meat, egg, or vegetable, dipped in *padek khouang* or other sauces and eaten. All Lao tribal cousins living along the northern stretches of Vietnam (Muong), Thailand, and the Burmese highlands share this preference. Dry dishes are normally eaten with such filling glutinous rice. Only a small percentage of Laotians, mainly urbanites, prefer the loose-grain rice, which they call *khao chao* or 'Chinese rice'. All Thais used to eat glutinous rice before their migration south in the fifteenth century.

Centuries of absorption of Chinese ingredients, cooking methods and fine-tuning in the Muong culture have given Vietnamese food its own unique taste. Its Chinese style is highly marked by the service of chopsticks, bowls, and a general southern Chinese characteristic. The Vietnamese spring roll has an innovative filling of Chinese ingredients not found in Chinese spring rolls. It is wrapped in 'rice paper', *banh trang*—thin rounds of rice flour paste sun-dried on bamboo mats—instead of the Chinese wheat-flour wrapper. The refreshing *nuoc cham* is a dip made by ingeniously flavouring the fish sauce, *nuoc mam*, with raw garlic, lime juice, sugar, and chilli. One ingredient in *nuoc cham* is an essence from the cicada, *ca cuong*, which is prized by all Vietnamese gourmets for that extra kick in taste.

Food in central Vietnam has a more sophisticated style in presentation, a legacy from its ancient position as the seat of the Chinese-style Vietnamese ruling dynasties. With better varieties of fresh fruit, vegetables, rice, and seafood, southern Vietnamese cooking is richer and more colourful than that in central or northern Vietnam. Many fresh raw herbs and lightly cooked vegetables are eaten daily in large amounts. A Hindu–Muslim style lingers here with Indian curry spices, chillies, and a generous hint of

lemon grass and coconut. Half of the Malay-speaking Chams are Muslims who are descendants of the ancient Hindu Champa people converted in the tenth century through close contact with the archipelago. Both Hindu and Muslim communities live in close proximity. They have enjoyed cultural and economic harmony for centuries, as the Muslim Chams breed pigs to sell to the Hindus, who in turn breed cows for them.

The Countries of the Archipelago

Malay, Indian, Chinese, European, and Eurasian styles are evident in many a meal in the more cosmopolitan Malay archipelago. In general, however, a sweet and spicy pungency wafts up from the region's 'celebration' of the bountiful coconut. Sweet coconut meat and milk pervade the whole region's savoury meals or snacks, together with chilli, palm sugar, lemon grass, galangal, and *belacan*. There is much more curry variety as well as braised dishes with lots of gravy, and open-fire grilling or barbecuing—*panggang*—is prevalent. Meat or fish is cooked bare over charcoal fire, or heavily seasoned, then wrapped in leaves, and grilled or buried in charcoal. The well-known Indonesian satay traces its origins to the Middle Eastern *kebab* brought by the Arab Muslim traders. Fine strips or cubes of marinated beef, chicken, or mutton are skewered on coconut leaf-rib sticks, and grilled over charcoal fire. Satay is accompanied by sweet and spicy peanut-coconut sauce, raw onion, and cold compressed rice (*ketupat*) and cucumber to cool the palate. To the Indonesian Chinese, 'satay' is derived from the Chinese phonetic transcription of 'three pieces'—*sa teh*— in reference to the three strips of meat on each stick. The Thai say it is a corruption of the English word 'steak' for the beef used. This hallmark of Indonesian–Malay cooking is avidly adopted by all other South-East Asians, who vary it with pork. The classic satay man fanning his portable tin stove of glowing charcoal with a palm-frond fan (Plate 4), with sweet aromatic smoke rising from the neat rows of grilling satay, is an appetite-whetting sight all over the region, particularly on festive occasions.

Indonesia, like the Philippines, has thousands of volcanic islands

4. A satay seller with a palm-frond fan serving his customers; photograph by Hedda Morrison. (Courtesy of Division of Rare and Manuscript Collections, Carl A. Kroch Library, Cornell University)

named and unnamed, the most historically famous being the Moluccas. Despite 350 years of Dutch presence in the republic, no strong Western culinary influence is evident in Indonesian food. On the other hand, the eighteenth-century Dutch planters were greatly taken in by the exotic Javanese food, which inspired their *rijstafel* discussed in Chapter 5, and which explains the availability of Indonesian food ingredients in Holland. Hinduism pervades the colourful Javanese culture, and remains the dominant religion in Bali. Pork is a favourite Balinese food, usually cooked with sweet hot spices. The ultimate pork dish is the *babi guling*—a festive speciality of whole pig stuffed with a surfeit of spices and ingredients, and spit-roasted till golden (from turmeric rubbed on the skin).

15

Furthering the cause of inexpensive but healthy food, the Indonesians have created the *tempe*—cooked soya bean coated with a fermenting agent for two days to break down its indigestible elements and release its protein content. The result is a white spongy cake of crunchy but insipid soya beans, which is cut up and fried to create savoury yet exceedingly economical and nutritious Malay dishes.

In the seventeenth century, the Minangkabau people migrated from Padang in west Sumatra to west Peninsular Malaya, which accounts for the culinary similarity between these two regions which are well known for their hot or *pedas* dishes in the Padang style. Among the South-East Asian countries, Malaysia has the most varied culinary styles and flavours, each state taking pride in its own unique taste. This includes Sarawak and Sabah in Borneo, where meals are further enriched by the Dayak's jungle flavour. The Brunei Sultanate in between the two shares a similar Borneo Muslim-cum-Malay style. The Indian population of Malaysia contribute their tandoori cooking, dhal dishes, mutton, fish, and vegetable curries, and bread like *roti pratha* and *naan*. The making of the *murtaba* involves flinging a ball of kneaded dough into the air, resulting in a thin wrapper, which is filled with meat or vegetables and then cooked. The Straits Chinese of Malacca, Penang, and Singapore are famed for their refined cooking, which, in essence, is a distillation of the most meticulous use of Chinese and Malay ingredients and cooking skills.

The Chinese form the largest immigrant population in Malaysia and Singapore, while the Indians come in second. John Turnbull Thompson in *Some Glimpses into Life in the Far East* (1864) has a witty account of the multicultural nature of a *kenduri* or feast he attended in the early 1800s. According to him, the Malays

with their tubs of white rice, bowls of curried buffalo, and sauces of sambals ... dug into the contents with their right hands.... The Chinese with their kits of rice, and cups full of stewed pork, shovelled mouthfuls into their wide open jaws.... Then again, the Hindoos eat their simple, quiet, and unsocial meals.... Yet the aroma of their meals is agreeble; and they grunt with satisfaction ... in a manner that is not to be described to ears polite.

In the southern Philippines, the Mindanao populations maintain a Malay-Muslim food culture, with rich coconut, spicy curries, *sambal* dishes, and sweets. Except for pepper, minimal spices are used in the northern Philippines. The Filipino's favourite *pancit* snacks are Chinese noodles of all kinds (Colour Plate 5). The Chinese spring roll, with cooked filling in wheat-flour wrapper and eaten without further cooking (as the *popiah* in Malaysia and Singapore, and the *paw pia* in Thailand), is given its own local character with the use of the coconut palm 'heart' or *ubod* (Chapter 4), and the native name, *lumpia ubod*. *Lumpia Shanghai* is the deep-fried version.

Akin to mainland cooking (yet vastly different in taste or flavour), with fish and soya sauces as flavouring agents, Filipino cuisine also uses a sour base. Common 'souring' agents are vinegar, lime, tamarind, and *belimbing* (star fruit). A departure from the South-East Asian flavour is the Filipino use of olive oil for sautéing and stir-frying their dishes. Dipping sauces or *sawsawan* accompany every morsel of food eaten, and often the diners liberally create more to go over the cook's masterpieces. Spanish names grace dishes made of indigenous ingredients and distinguish the cooking methods. *Adobo*, with a subtle sour taste, is meat or fish marinated and cooked in garlic, palm vinegar, peppercorn, and bay leaf. *Paksiw* is meat braised and 'pickled' with vinegar and salt or sugar to last a few days without refrigeration.

To the Filipinos, the favourite meat is pork, and *lechon*, the golden roasted suckling pig, like its Balinese counterpart, is a fiesta speciality and standard Christmas dinner fare. The name *lechon* comes from the Spanish *leche* for milk. Like all festive fare, it is roasted for hours over an open-ground fire, with diners taking turns to partake of it amidst drinking, fun, and repartee. Ingrained in the indigenous food habit is the relish for *balut* or boiled half-incubated duck eggs, usually sold by pedlars. The half-formed bird and dark fluids are swallowed with great gusto.

3
Basic Ingredients and Spices

IN the rich diversity of South-East Asian cuisine, a remarkably large repertoire of similar, fresh, basic ingredients is used throughout in endless combinations, and with varying cooking methods. Finely sliced or pounded into a mixture with the mortar and pestle, these ingredients form the spicing and seasoning base for all meat, fish, or vegetable dishes that accompany the plain staple—rice. Fish sauce and soya sauce provide a nutritious flavouring salt; tamarind and limes add an appetizing natural sour taste; coconut milk binds the sharp flavours; and palm sugar balances the spiciness. Two or three of the basic ingredients serve to cook the simplest dish. The most elaborate spread of festive fare calls for the whole range of the same, while the addition of Indian spices enriches the innumerable varieties of curry.

It is often said that the best 'restaurant' in South-East Asia is found in the homes, where earth-fresh ingredients like turmeric or galangal (commonly known in the West as galingale) and lime or chilli (among other tropical vegetables and fruit) are harvested from the bushes and trees in the back garden. Many of these plants are perennials that grow and propagate abundantly in village and kampong grounds and backyards. Along with the coconut palms, they have been extolled as 'gifts from nature', requiring little care to thrive and yield year-long provisions. Yet they are more than culinary ingredients. John A. Barrow, in *A Voyage to Cochin China in the Years 1792 and 1793* (1806), noted that in Java many spice plants were grown 'for their beauty or their fragrance', amongst which the lemon grass 'is used as an ingredient in the favourite dish of currie'. Over this aestheticism is the age-old South-East Asian inclination to use the same spice plants that season their stews or soups as simple home remedies and preventives for minor ailments.

Underlying the simplicity and complexity of South-East Asian cooking is the balanced use of the ingredients and spices to com-

plement and contrast, or to fire up flavours and colours. The harmonizing of taste, the ritual use of and respect for fresh food, the cooking method, general knowledge of food cure, and the indigenous ways and rhythms of life have been strongly retained in South-East Asian cooking despite the last three centuries of European colonial influences.

Pepper (Piper nigrum)

The name 'pepper' comes from the Sanskrit *pippali* meaning 'berry'. The 'black pepper' (*Piper nigrum*) was introduced into Sumatra and Java from India by the early Indian traders. Its Malay

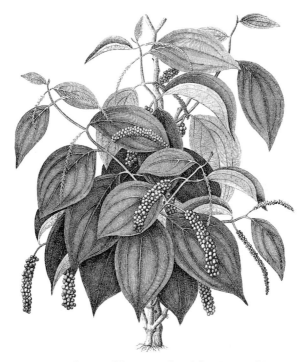

5. A pepper vine, from William Marsden, *The History of Sumatra*, London, 1783.

name is *lada padang* or *lada padi*. Both black and white pepper come from the same tropical 'black pepper' vine (Plate 5). Sun-drying the underripe, green pepper berries yields black pepper with a more stringent 'bite' from the resin in the shrivelled skin. White pepper comes from soaking ripe, red berries to remove the pericarp before sun-drying. Both types, as well as the fresh, green berries, are used in small quantities in cooking. Before the Portuguese brought chilli to Asia in the sixteenth century, pepper must have been the main 'hot' spice in South-East Asian cooking. The *kurmah* or *korma*, a Malay–Indian 'white' curry (without chilli), is a classic dish in which the heat and 'bite' are provided by the white peppercorn. Pepper's hot flavour comes from its chemical oils. It is regarded as 'heaty' by some, but is a warming stimulant that prevents constipation and a carminative that relieves stomach gas. It has also been used as a natural pest repellent in linen chests and kitchen drawers.

Chilli (Capsicum frutescens)

On coming upon the Americas instead of the Orient in 1492, and finding the chilli instead of the black pepper, Christopher Columbus wrote in his report that the chilli 'is stronger than pepper'. Defensively or unwittingly, he had declared that it could be more valuable than the black pepper. Introduced into Asia in the sixteenth century, the chilli has since thrived and supplanted the pepper in giving vigour and colour to Eastern cuisines (Colour Plate 6). It is described by William Marsden in *The History of Sumatra* (1783) as the native's favourite ingredient 'which in preference to common or black pepper, is used in their curries and with almost every article of food'. Naturally, the Malay names for chilli are *lada merah* (red pepper) and *cabai* or *cabi*. 'Chilli' comes from the Maya and Aztec languages. Its common name 'capsicum', from the Greek *capto* meaning 'I bite', aptly describes the temperament of this long and narrow 'hot' fruit of the perennial chilli plant. The green and red pepper of the temperate clime is also called capsicum, but it comes from the Latin *capsa,* meaning 'box', which again aptly describes this big hollow fruit. Chilli and its thousands of species

20

grew wild in the Mexican valleys 9,000 years ago and by 5000 BC they were cultivated by the Central American natives for food and medicine.

Fresh, green chillies have a gentler 'heat', ripe, red ones give varying degrees of 'fire'—the larger the fruit, the less it burns—while the crinkly dried, red chillies are no less powerful. At a South-East Asian meal, a jar of dried-chilli flakes or freshly cut green and red chillies is the spicy counterpart to the salt-and-pepper shakers of the West. Many early European travellers' first encounter with the South-East Asian use of chilli was invariably one of shock. Augusta de Wit in *Java: Facts and Fancies* (1912) recalled how she eagerly 'fell to' her heaped plateful of food (from the 'rice table') 'all strongly spiced, and sprinkled with cayenne', only to find her lips 'smarting with the fiery touch of the sambal; my throat the more sorely scorched ... my eyes full of tears'. She was to relieve herself from this 'abject misery' with a pinch of salt on her tongue.

The 'bite' in chilli comes from its alkaloid—capsaicin—most of which is contained in its placental tissues and seeds. The smaller the chilli fruit, the sharper the concentration and bite. The Thai *prik kee nu*—literally 'mouse-shit pepper', which the Malays call *cili padi* (or 'bird chilli') because of its rice grain size—is preferred for the intensely spicy soups and sauces. Rich in vitamins A and C, the chilli consumed in moderation is regarded as a healthy, anti-bacterial spice for the digestive system. One popular notion held is that eating chilli acts like a natural air-conditioner to the body, as the capsaicin is a diaphoretic that induces perspiration which rids the body of its humidity.

The Ginger Group

The perennial herbaceous ginger (*Zingiber officinale*) is native to Asia. Mature ginger roots have a higher content of ethereal oils which help to digest fatty food, keep the meat intact while cooking, and get rid of fishy or gamey smell. Young tender roots are eaten raw or candied for their delicate texture. Early Chinese traders were known to keep potted ginger plants on board their

ships, as fresh rhizomes are always preferable for cooking. Modern laboratory experiments have found the ginger capable of preventing motion sickness and vertigo and of cleansing the system through the skin and bowels. A traditional prescription for a cold is ginger boiled in water and palm sugar for a warming drink. To the Laotians, the rich yellow colour of mature ginger symbolizes gold in their offerings to the spiritual world.

Turmeric (*Curcuma domestica*) is *kunyit* or *kunci* in Malay, or 'yellow ginger' in Chinese (Colour Plate 7). This smaller, orange-colour rhizome, used in fresh, dried, or powdered form, is indispensable in rendering to curries and vegetables a beautiful yellow colour and a pleasant camphory and peppery aroma. The turmeric's golden hue signifies happiness, and the plant plays an important role in South-East Asian festive and religious rites, such as Muslim wedding ceremonies and births. The significance of the Indonesian *nasi tumpeng kuning*—large cones of steamed rice coloured yellow with turmeric and deliciously garnished—may be traced back to ancient Hindu rituals. A Balinese legend says that the god Siwa originally gave the people rice of the four sacred colours—white, red, black, and yellow. The spirit Batara Wisnu Sangawerti ate all the grains except the yellow ones, which he planted. A turmeric plant sprouted from that, and ever since then ceremonial rice has to be made yellow with turmeric to complete the sacred colours. As yellow is the colour used in Hindu worship and turmeric is a medicinal herb, the act speaks of the spiritualism and practicality of South-East Asian food cultures. Malay grandmothers were known to chew and spit turmeric juices in various places (usually seven) in the house where children were playing and to rub a turmeric paste on the children's stomach to 'ward off evil spirits'. The latter may be based on the virtue of the ginger family as a carminative.

Both the Greater Galangal (*Alpinia galanga*), a harder ginger root commonly known as *laos* or *langkuas*, and the Lesser Galangal (*Kaemferia galanga*) or *kencur* are used more than the ordinary ginger by Indonesians (Plate 6). The galangal's white crunchy flesh and delicate, sharp flavour help to scent and sweeten curries and braised meats, and it is as good as the ginger for settling stomach disorders

22

6. Galangal, from Eugen Kohler, *Medizinal-Pflanzen*, Gera–Untermhaus, 1887.

and for curbing nausea. The galangal is also believed to be effective in reviving the poor appetite of sick elephants.

Onion (Allium cepa) and Garlic (Allium sativum)

These potent bulbs are the most basic and essential of ingredients used in substantial amounts in all South-East Asian cooking, from the simplest to the most complicated recipes. For uncooked

sambal and seasoning pastes, they are roasted over fire before being pounded. Thinly sliced and deep-fried till crispy and pungent, they are commonly used to garnish all kinds of dishes throughout the region. Both bulbs belong to the chive and leek family and are known to South-East Asians for inhibiting the growth of bacteria and intestinal parasites.

Candlenut *(Aleurites moluccana)*

The creamy, nutty flavour of the candlenut (Plate 7) of the candleberry tree enriches the texture of fish, meat, or vegetable curries. It is called *buah keras* in Malay, meaning 'hard fruit', and its beige, waxy meat is encased in a rock-like shell which is cracked by roasting over fire. The nuts are sold ready shelled or in paste form with curry spices. In some dishes, the candlenut is used in place of the coconut.

7. Candlenut or *buah keras*; engraving, from William Marsden, *The History of Sumatra*, London, 1783.

24

Lemon Grass (Cymbopogon citratus)

The lemony scent of the *serai* or lemon grass pervades all South-East Asian curries and barbecues. Depending on the amount used, it can give a striking flavour as in many Thai dishes, or a gentle hint of fragrance. Its *citral* oil is released by bruising its long, slim bulb-like base or grinding its soft inner sheaths. When spliced, the whole fibrous stem makes a fragrant, disposable barbecue brush. An ancient Indonesian belief holds that lemon grass should be cut by young girls, as only their purity would bring out the best of the plant's fragrance.

Tamarind (Tamarindus indica)

The name 'tamarind' is Arabic for 'date of India'. Its common Malay name *asam* indicates its Indian–Burmese home. Originally from Africa, the tall and spreading tamarind tree yields an annual, prolific harvest of legume-like pods with brown, stringy pulp (Colour Plate 8) which is mixed with water to make 'tamarind water' for cooking. Whole ripe, sweet pods are eaten fresh or as dried snacks, and the flowers and leaves are also used in cooking and for making salads. Tamarind gives a delicate tartness to curry dishes, known simply as *asam* in Malay, as well as to *sambal*, satay sauces, and soups, such as the Penang *laksa*, the Burmese *mohinga*, or the Filipino *sinigang*. Its flavour is described by Donald M. Campbell in *Java: Past and Present* (1915), as 'neither sweet nor acid but a delicious indescribable something between the two'. The fruity, sour taste in *asam* gravy, iced fruit drinks, soup, or tamarind candies whets the appetite and quickens the digestive glands on hot lethargic days. The Burmese say that in hot weather, sitting under the tamarind tree will cool down the body system.

Lime (Citrus aurantifolia)

The fruit's generic name *limau* comes from the Persian and Arabic 'lemun' for 'lemon'. The lime is one of the oldest cultivated plants in Asia and many of its species thrive well in the tropics. They are used

throughout the region in fish dishes, *sambal*, salads, noodles, and dipping sauces, and in thirst-quenching lime drinks. Most generously used are the marble-sized, zesty *limau kesturi*, but in the Philippines, the native orange-like *calamansi* is preferred. The larger *limau purut* or Kaffir lime has citric-rich, bumpy skin, and thick, dark, oily green twin leaves, both of which are used in Thai curries and soups. The leaves impart a rich fragrance to Malay curries and the *otak-otak*—pounded spicy fish meat wrapped and roasted in banana leaf.

Dried Fish and Shrimp Paste

Surplus seafood harvests are preserved for the off season. Large and small seawater fish, freshwater fish, and prawns are salted and sun-dried, to produce the salty white bait (anchovy) or *ikan bilis*, dried prawns, or fermented fish. They keep for a year, providing some protein to inland dwellers and adding a saltish 'sweet' aroma as flavouring ingredients in cooking or as condiments. Although they are preserved food, they are nevertheless sought for their freshness in taste and colour.

Another preservation process is to salt and ferment the shrimps and then pound and shape them into the hard shrimp paste— Malaysian *belacan*, Indonesian *terasi*, and Thai *kapi*. *Belacan* has an overpowering smell that yields a tempting aroma when it is stirred in hot oil with onion, garlic, and chilli to season almost any vegetable. It is the *belacan* pounded into the spice mixture that gives South-East Asia's coconut-rich curries their saltish shrimp sweetness. For a pungent accompaniment, it is roasted over charcoal fire, pounded with chilli, and softened with lime juice. Its innocuous complement of hot, sweet, salty, sour, and bitter tastes rouses the appetite for plain rice. As with other fermented foods, appreciating it is an acquired taste. Marsden called it 'a species of caviare' but opined that it was 'extremely offensive and disgusting to persons who are not accustomed to it'. Isabella Bird, in *The Golden Chersonese and the Way Thither* (1883), recalled that on her boat trip in Malaya where she had 'a slim repast of soda water and bananas', she watched the boatmen prepare their curry and the 'tastiest

condiment *blachang*—a Malay preparation much relished by European lovers of durian and decomposed cheese ... [with a smell that is] penetrating and lingering'. According to food analysts, *belacan* supplies a high dosage of calcium and protein, which is not surprising considering that the whole fresh catch, carapace, bones and all, goes into its manufacture.

Fish Sauce and Soya Sauce

Fish sauce making is a South-East Asian skill as soya sauce brewing is Chinese. Fresh or seawater fish is layered with salt in large jars which are sealed and left in the sun and wind for a month. The clear, dark amber liquid, a result of osmosis, is drained off and matured for months before use. Like soya sauce, it is rich in protein, vitamin B, and salt. Chinese dark, sweet soya sauce, *kecap manis*, and light, salty soya sauce, *kecap asin*, are the main sauces used in Malay-style cooking as well as dips, though some fish sauces are used for particular dishes. The *kecap manis*, sweetened with palm sugar or molasses, gives a rich colour and sugar-sweet taste to stews or fried food while the light soya sauce replaces salt in many dishes. Incidentally, the word 'ketchup' for tomato sauce comes from the early Indonesian Chinese word *ketjiap*, which literally means 'sauce' (made from pressing fruits).

The Spices

The Indian and Mediterranean spices adapted to South-East Asian curries are the coriander seeds or *ketumbar* and the aniseed, cumin, fennel, and caraway seeds. In whole or powdered form, they are sold by spice vendors and in shops from wooden, compartmental spice boxes or gunny sacks. A regular feature of the region's open markets is the Indian vendors' wet spice stalls, easily found by their nose-tickling redolence, and attractive, colourful mounds of pastes and ground ingredients. The spices are well soaked and finely ground, traditionally by heavy stone rollers and slabs, most of which have been replaced by electric mills and grinders. These pastes, or *rempah* in Malay, are 'custom mixed' as each individual

buyer spells out his or her need for meat, fish, or vegetable curry, and the preference for more or less of one spice or another. South-East Asian curries differ from the continental Indian curries in their choice of spices, with coriander seeds and cumin seeds making up the bulk. The firm wet spice pastes are appreciated for their fineness, their day-fresh quality, and their convenience. Where time and labour permit, spices are freshly ground at home with the mortar and pestle, the Indian-style stone slab and roller, or the electric spice miller. Freshness aside, the right proportion of spices and fresh basic ingredients for the authentic home-cooked dishes owes its speciality to family recipes handed down by oral instructions through many generations. The packaged and branded curry powder is a product of British–Indian colonial influence where a standard formula of twenty or more spices is ground and commercialized for the convenience of the modern kitchen. As Marsden put it: 'Their dishes ... prepared in that mode of dressing to which we have given the name of curry ... is called in Malay language *gulei*, stewed down with certain ingredients by us termed curry powder.' The many varieties of curry powder in the South-East Asian markets reflect the diversity of local or regional preferences.

Cloves and Nutmeg

Cloves, nutmeg, and cinnamon from South-East Asia and saffron from India were often referred to in Old French as the 'four species' of condiment or aromatic plants from the Orient. It is believed that the word 'spices' is derived from the often-repeated 'species'. Spices are regarded as protective food against diseases and infection because of their antiseptic properties, generated by jungle plants in their barks, leaves, blooms, and berries to ward off predators and combat other natural poisons.

Cloves and nutmeg have a long history in the spice trade, being among the most expensive aromatics carried by the spice traders from South-East Asia to Europe and China. In the early centuries, they were gathered from the wild (and later cultivated) on the small volcanic islands of the Moluccas, north-east of Java. The natives bartered them with the Indian, Chinese, and Javanese

traders for rice, metal tools, Chinese porcelain, medicine, and cloths (batik and Indian calico). Through these middlemen, cloves and nutmeg reached Europe with an exotic value of one hundred times their original cost. Sixteenth-century European explorers and travellers marvelled at their abundance: '... such quantities of these cloves that they never can finish gathering them....' Two cinnamon sticks, three nutmegs, and twelve cloves were the ensignia of a coat of arms presented by the Spanish Emperor, Charles V, to the captain of the ship that finally arrived

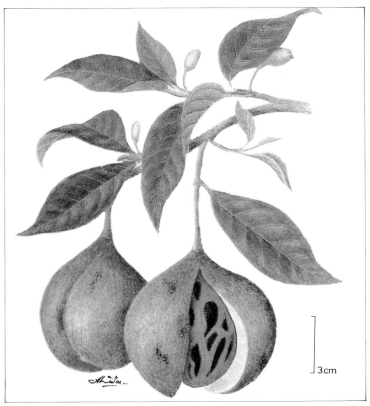

3cm

8. Nutmeg, from W. Veevers-Carter, *Riches of the Rain Forest*, Singapore, Oxford University Press, 1984.

back in Spain after going round the world in 1522. The Dutch in Indonesia controlled the lucrative trade for a time in the eighteenth century by restricting clove and nutmeg cultivation to the Moluccas islands and by burning thousands of tons of surplus cloves in Amsterdam. The two spices are, however, hardly used in Indonesian cooking; in other South-East Asian curries, they are added whole or ground in small amounts for a creative subtlety in flavour.

The clove (Colour Plate 9), one of the spices in the after-meal 'betel chew' used throughout South-East Asia, is the dried flower bud of the tropical clove tree (*Eugenia caryophyllus*). Its spicy, sweet chemical oil is extracted for medicinal, dentifrice, and cosmetic manufacture. In Indonesia, cloves go up in smoke as a 50 per cent component of the nation's favourite crackling cigarette called *kretek*.

The nutmeg (*Myristica fragans*) is the kernel of the fruit of the beautiful and fragrant nutmeg tree (Plate 8). The fruit's thick outer coat is candied as a crunchy sweetmeat, while its second coat, the red aril, yields the spice mace. For spicing a curry dish, a minute amount of nutmeg is freshly grated from the seed with a nutmeg grater. Like the clove, the nutmeg is known to be analgesic and stomachic, and is used more for medicines, perfumes, and ointments than in cooking.

The Chinese spice used throughout the region is Five Spice Powder or Serbuk Rempah Cap Lima in Malay. It consists of star anise, fennel, clove, cinnamon, and Chinese Sichuan pepper. Used discriminatingly, it gives an authentic spice flavour to Chinese-style meat rolls, roast duck or pork in dark soya sauce, and savoury cakes and snacks.

4
Food from the Palms

This tree [the coconut], and indeed most of the palm tribes as the date, the sago and the areca, all supply him with solid food.

(John A. Barrow, *A Voyage to Cochin China in the Years 1792 and 1793*, 1806)

The Coconut (Cocos nucifera)

BOTANICALLY misnamed in Latin, the coconut is a drupe rather than a nut (Plate 9). The Dutch's *Klapper* is from the Malay *buah kelapa*, which puns on its similar round shape to *kepala*, the head. Marco Polo in 1292 described it as 'large as a man's head'. (The expression 'use your coconut' comes to mind.) 'Coco' came from the Portuguese who found that the three germination spots on its hard shell gave it an impish look.

Uses of the coconut palm, like the bamboo, are legion, from building materials to cosmetics to whole foods, oils, fuel, medicines, crafts, rural utensils, and cutlery. Brooms and satay sticks are made from the spines of the leaves while *ketupat* bags for cooking compressed rice for satay are woven (as one of the skilful native crafts) from its young leaves. Before modern measuring scales were introduced after the 1950s, a whole coconut shell was a *calok* while a *cupak*, about 0.6 litre, was half a coconut's scoop. In parts of northern Malaysia, ensembles of coconut *kertuk*—hollowed-out coconut drums—can be heard at harvest time. In secular ceremonies and religious rites, offerings of coconut, rice, and sugarcane always feature symbolically in thanksgiving for the gods' generosity. In Balinese temple offerings, coconut palm (and lontar palm) leaves are a major decorative material.

It is at the South-East Asian table that coconut excels in its use. Its immature flowers yield an innocently refreshing toddy which is

31

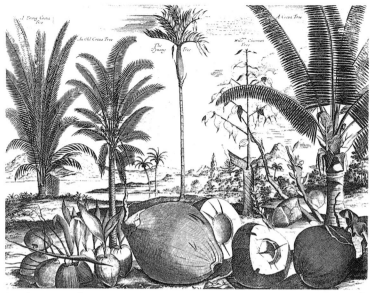

9. Coconut palms and fruits and a cinnamon tree; lithograph, from
 Johan Nieuhof, *Voyages and Travels to the East Indies, 1653–1670*,
 Singapore, Oxford University Press, 1988; reprinted from the
 second part of *A Collection of Voyages and Travels . . .* , London,
 A. & J. Churchill, 1704.

boiled and crystallized into the sandy-textured brown palm sugar—
the jagged *gula melaka* or *gula java*—used throughout the whole
region's cooking, in savouries or sweets. When fermented and
distilled, the same toddy produces a heady palm wine, arrack or
tuak (Colour Plate 10), while a further process produces palm vine-
gar. Palm cabbage, or 'palm heart', the *ubod* in the Filipino *lumpia*,
is procured by felling the palm. It is crunchy and creamy tasting
and is much favoured in salads. It is unsurpassed when cooked in a
coconut milk curry.

The young green coconut provides a sweet, refreshing beverage
known to South-East Asians as an antidote to 'poisons'—arguably,
an antiseptic liquid with a diuretic effect. Lightly clouded with car-
bon dioxide, it contains sugar and salt. Its young, translucent gel-

like kernel is called 'spoon coconut' by some, as eating it with a spoon is necessary. The Thai cook the whole thing—meat and the tender shell—in a spicy chicken dish.

Coconut cream or milk squeezed from the shredded thick, white meat of the mature fruit is chiefly used in cooking. Coconut milk binds well with all the basic ingredients and spices, 'mellowing their fire' while adding a natural milky sweetness. It is this combination that makes South-East Asian cuisine different from that of the Pacific islanders using as much coconut, and from subcontinental Indian cooking using similar spices.

Before the advent of the ubiquitous coconut shredding machine in the markets and provision shops, coconut meat was shredded at home, as it still is in remote rural areas. A round spiky blade is mounted into a stool-like wood block, which is creatively shaped into a *kabayo* or horse in the Philippines; it is called a 'rabbit' in Laos and Indonesia (though it may not be shaped like one). The grater holds the halved coconut over the up-tilted blade and scrapes the meat into a basin below. Fresh coconut meat pan-fried till brown gives a nutty flavour to dry curries like the beef *rendang*. Stir-fried with lemon grass, chilli, and sugar, it is a condiment that makes a plain vegetable meal palatable. A great amount of rice and coconut milk-based sticky snacks are rolled in freshly shredded coconut for extra crunch, flavour, and easy handling. *Dodol* is a Malaysian festive candy, caramel-like and chewy, made by kneading coconut cream and palm sugar with glutinous rice flour over a slow fire. In curry dishes, the thinner milk is used as cooking liquid and the thick one is added at the end to retain its fresh flavour. Like dairy milk, coconut milk curdles and spoils the dish if it boils over, hence curry pots are never covered while cooking. In some Thai and Indonesian curry dishes, the meat and spices are simmered in coconut milk until the oil is 'extracted', and the whole is sautéd in it as it cooks, with delectable results. Coconut oil, freshly rendered by hours of patiently simmering coconut milk, is used in all Malay cooking. It has a 60 per cent saturated fat content. (Pork oil is preferred in most mainland home cooking although it is being replaced by the more convenient, commercialized vegetable oil.)

Packaged or home-frozen coconut milk are wonderful standbys, but conservative cooks frown upon using them when fresh ones are available. Frozen or chilled shredded coconut tastes rancid to discriminating taste buds used to the natural freshness of South-East Asian food.

The Sago (Metroxylon sagus)

In Charles Allen's *Tales from the South China Seas* (1983), a British colonial officer's wife, Nancy Madoc, describing a sumptuous Sunday curry tiffin in early eighteenth-century Malaya, wrote that the dessert was 'a cold sago with two sauces, one coconut cream and the other gula ... an absolutely delicious sweet. After you'd had all that all you could do was long to get away and pass out on your bed for the rest of the day.'

Sago has to be 'harvested' from the tall and thick semi-wild *sagu* palm before its fifteenth year, when it would die upon spending its heavy starch reserve in flowering and seeding. The cutter fells the whole palm trunk, strips off the hard bark, and grates the soft pith to a coarse meal, which is washed in running water. The starch, separated from the woody fibres and settling in the water, is scooped out to form mounds of paste and sold wrapped in its own sheaths or in banana leaves. Sago pellets and grains are formed by pressing sago paste through a metal sieve and shaking them in trays or, primitively, rolled in mat bags so they form into balls as they dry (Plate 10). This is the commercial pearl sago that is mainly exported to the West. Much of it is also consumed throughout South-East Asia in the form of steamed snacks and sweets, the more well-known being *sago gula melaka*.

Sago, with its 85 per cent starch content, is branded an energy food. This pale nutritional content is enriched with coconut milk, palm sugar, and eggs when it is made into cakes and cookies. In the Moluccas, it is cooked into a sticky snack served from banana leaves, or a warm starchy porridge called *papeda*, eaten with fish sauce, shellfish, and chilli. Sarawak's Penan, Sabah's Kadazan, and other similar tribes of Indonesian Borneo eat a similar sago porridge, coaxing the starchy lumps with wooden or bamboo chopsticks.

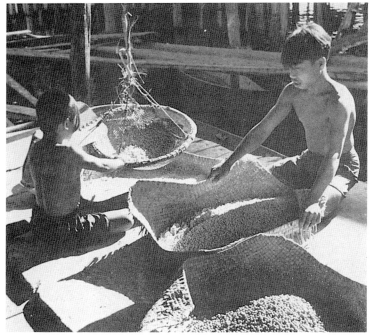

10. Boys making sago pearls; photograph by Hedda Morrison.
(Courtesy of Division of Rare and Manuscript Collections,
Carl A. Kroch Library, Cornell University)

Lamatan, or sago starch, gave the ancient name Kalimantan to the island of Borneo.

Sago starch is a temporary substitute staple whenever the rice harvest is poor or late in areas where sago is abundant. The flour is used in manufacturing long rolls of fish or prawn cakes that are eaten freshly cooked, or sliced and sun-dried into the hard crackers called *krupuk* or *keropok*. These keep indefinitely and are deep-fried into puffy light crackers, with which the Indonesians garnish their salads or curries for a crunchy and delightful effect. *Keropok* is one of the traditional New Year snacks for many South-East Asians.

Like the coconut tree, the sago palm yields more than food. Its fronds, plaited into *atap*, were once quality roofing material for

Javanese and Malaysian houses, and its palm sheaths are made into baskets for holding paddy. However, its rapid propagation in the many freshwater swamplands makes it an economical food plant. Each mature tree yields 300–400 kilos of wet starch. Its numerous seedless, ovoid fruits, translucent and chewy, are sold as palm or *atap* fruit in snack shops.

The sago starch extracting technique is probably more than a thousand years old, as Marco Polo when in Sumatra 'did at sundry times partake of this flour made into bread and found it excellent'. The Chinese encountered it in Malacca in the fifteenth century as the '*sha-ku* from some wild trees', and in the early 1800s, set up a pearl sago processing plant there. Sir Francis Drake, in the Moluccas in 1580, said that he 'receiued of them meale, which they call Sagu'. Ever since then, British colonists have served the *sago gula melaka* elegantly in glass bowls with silver spoons, in their Sunday tiffin or on board their passenger steamships plying the South China Sea in the twentieth century.

The Areca (Areca catechu)

A Vietnamese saying goes that a piece of betel helps start a conversation. William Marsden (1783) noted that the Sumatrans serve it 'on all occasions; the prince in a gold stand and the poor man in a brass box, or mat bag'. A 'betel chew' or *sirih makan* is a sliver of areca nut (Plate 11) and a smear of slaked lime wrapped in a betel leaf. The packet is left in the mouth to be chewed at will, like a piece of chewing gum.

Betel chewing was until the 1960s common among South-East Asians as a relaxant after meals or, like coffee or tea, as a social activity at any time of the day. Mildly narcotic, the chemical in the areca nut slows down the bodily functions as gossip is exchanged, or as a marriage proposal for the eligible charges under one's roof is discussed. This ingrained habit has been mentioned by practically every Western traveller whose encounter with the betel chewer and his bright red mouth and spit was one of utter surprise. The lime (calcium hydroxide) releases the alkaloid chemicals in the areca, and the spicy *sirih* leaf (*Piper betle*), belonging to the pepper

36

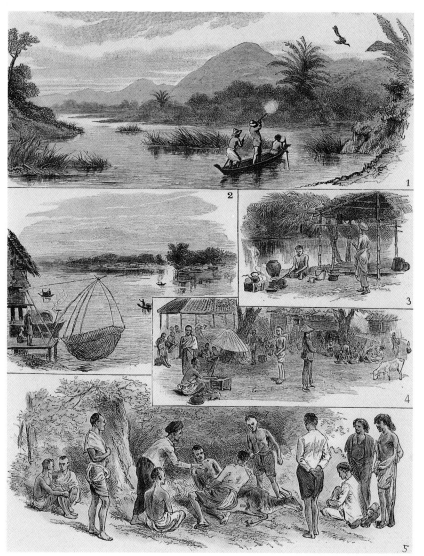

1. A collection of Thai scenes showing peacock shooting, fishing, outdoor cooking, marketing, and cutting up a deer. (Antiques of the Orient, Singapore)

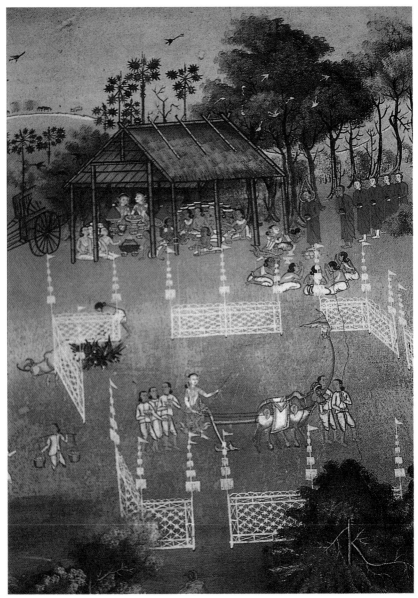

2. The royal ploughing ceremony; mural in Wat Mongkut; from Vatcharin Bhumichitr, *The Taste of Thailand*, New York, Macmillan Publishing Company, 1988. (Reproduced with the permission of Scribner, an imprint of Simon & Schuster, Inc.; illustration copyright © 1988 by A. N. Other; photographs copyright © 1988 by Michael Freeman)

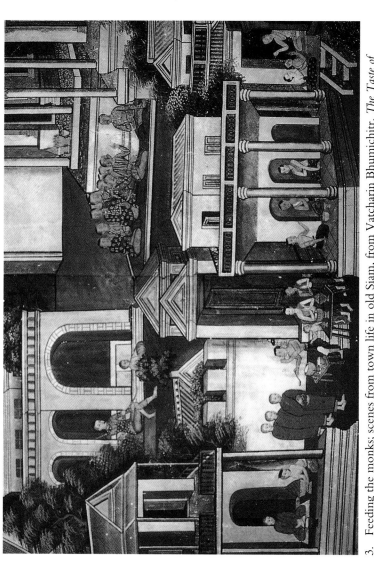

3. Feeding the monks; scenes from town life in old Siam, from Vatcharin Bhumichitr, *The Taste of Thailand*, New York, Macmillan Publishing Company, 1988. (Reproduced with the permission of Scribner, an imprint of Simon & Schuster, Inc.; illustration copyright © 1988 by A. N. Other; photographs copyright © 1988 by Michael Freeman)

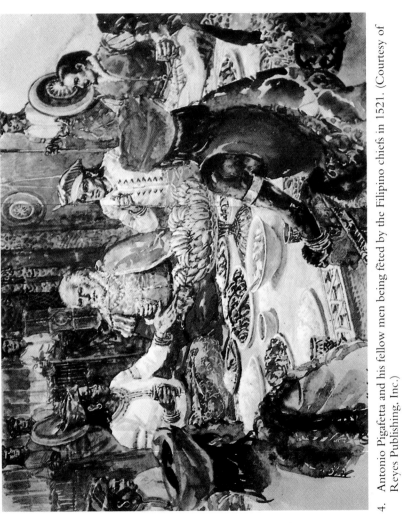

4. Antonio Pigafetta and his fellow men being fêted by the Filipino chiefs in 1521. (Courtesy of Reyes Publishing, Inc.)

5. A vendor selling Chinese noodles in the Philippines; drawing by J. A. Karuth, 1858. (Courtesy of Ayala Museum Library)

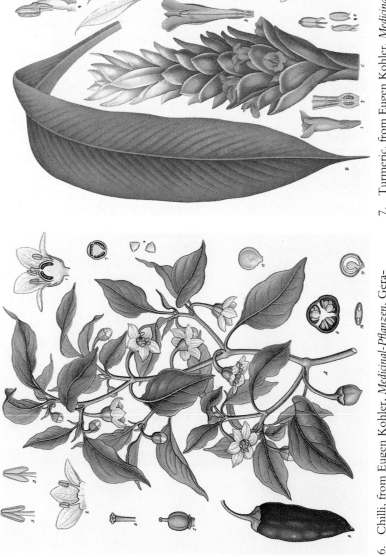

7. Turmeric, from Eugen Kohler, *Medicinal-Pflanzen*, Gera-Untermhaus, 1887.

6. Chilli, from Eugen Kohler, *Medicinal-Pflanzen*, Gera-Untermhaus, 1887.

9. Clove, from Eugen Kohler, *Medicinal-Pflanzen*, Gera-Untermhaus, 1887.

8. Tamarind, from Eugen Kohler, *Medicinal-Pflanzen*, Gera-Untermhaus, 1887. (Antiques of the Orient, Singapore)

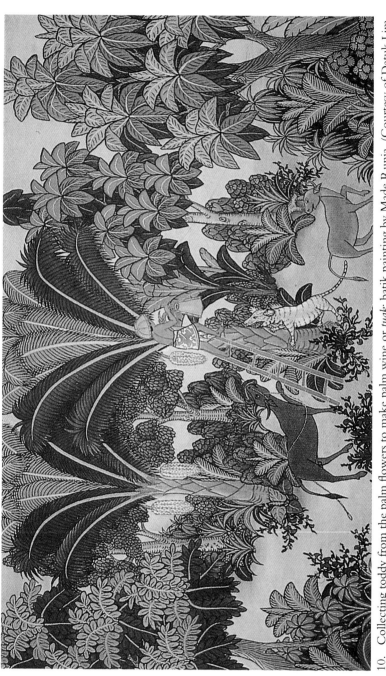

10. Collecting toddy from the palm flowers to make palm wine or *tuak*; batik painting by Made Runia. (Courtesy of Datuk Lim Chong Keat)

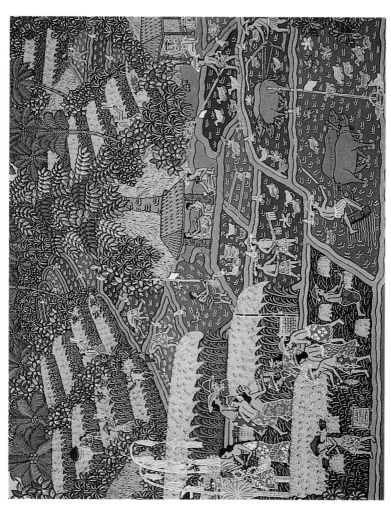

11. A colourful rice field scene; batik painting by Nyoman Londo. (Courtesy of Datuk Lim Chong Keat)

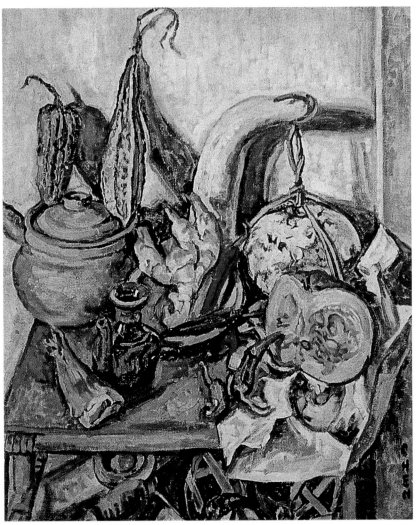

12. Vegetables and claypot; oil painting by Georgette Chen, *c*.1940–5. (Courtesy of the Singapore Art Museum of the National Heritage Board)

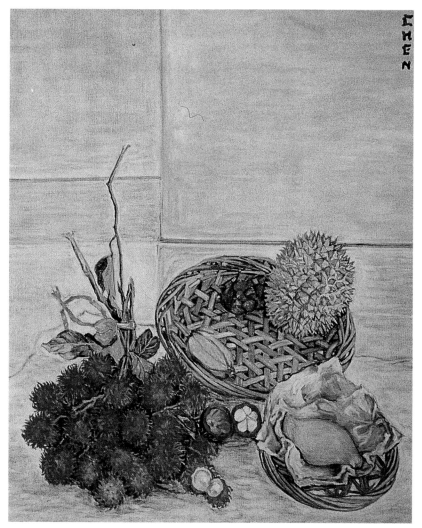

13. Composition with fruits; oil painting by Georgette Chen, *c*.1969. (Courtesy of the Singapore Art Museum of the National Heritage Board)

14. A man and his pony beside a mature jackfruit tree bearing fruit on all its three parts—branch, trunk, and root; drawing by J. A. Karuth, 1858. (Courtesy of Ayala Museum Library)

15. A market in Pekan; chromolithograph accompanying E. Nijland, *Handleiding voor de Kennis van het Volksleven der Bewoners van Nederlandsch Oost-Indie*, Leiden, Utrecht, 1897.

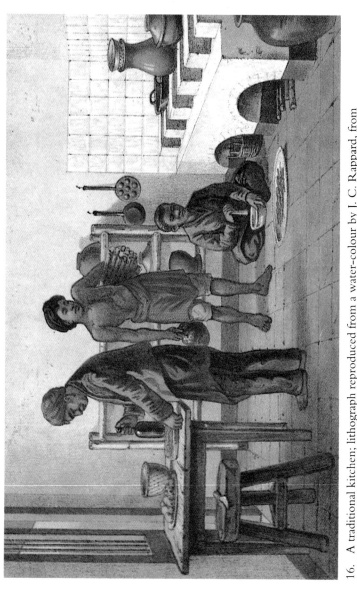

16. A traditional kitchen; lithograph reproduced from a water-colour by J. C. Rappard, from M. T. H. Perelaer, *Het Kamerlid van Berkenstein in Nederlandsch Indie*, Leiden, 1888.

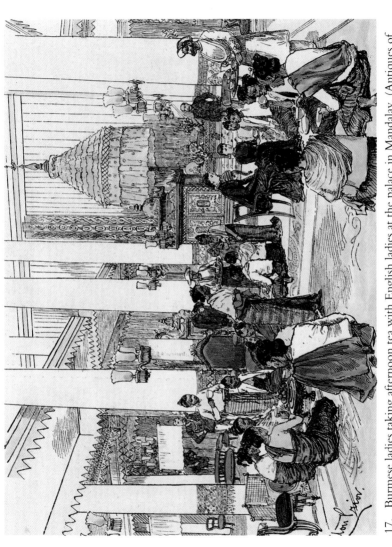

17. Burmese ladies taking afternoon tea with English ladies at the palace in Mandalay. (Antiques of the Orient, Singapore)

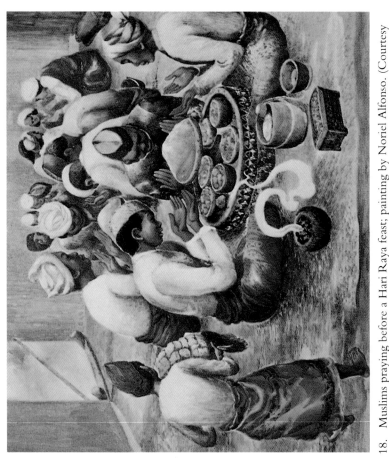

18. Muslims praying before a Hari Raya feast; painting by Noriel Alfonso. (Courtesy of Reyes Publishing, Inc.)

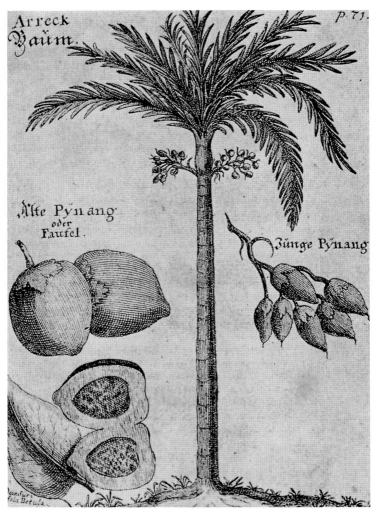

11. *Areca catechu* nut and palm, from Georg Meister, *Der Orientalis Indische Kunst-und Lust-gartner*, Dresden, 1692.

family, masks its astringency. The chemical turns the saliva red and blackens the teeth in time. A disconcerted Isabella Bird said that the mouth looked 'as if it were full of blood'. In culinary fares, the lime, or *kapur* in Malay, is used to give crispness to the chillies in the Sarawak *acar cili* (see Chapter 6) and to the batter of deep-fried bananas; it also renders an *al dente* texture to rice and coconut sweet cakes like the Malay *kuih koswee*.

Gambir, a brown extract from the *Unicara gambir* leaf, cloves, cinnamon, cardamom, nutmeg, turmeric, or finely shredded tobacco are added to enhance taste in different locales. Betel chewing freshens the breath, strengthens the gums, and generates saliva to aid digestion. A second-century BC Chinese text mentioned the slender, handsome, hundred-foot-tall areca tree as *pinlang* in a phonetical translation of the Malay *pinang*, after which Penang Island is named. Medicinally, the areca nut is used to paralyse and get rid of intestinal worms. Gambir is used to clean infants' mouths and gums. *Kapur* is used as a soothing rub for sore throat and coughs, for quelling insect stings, and as an abdominal massage on women after childbirth. The whole 'chew' is 'sometimes spat out onto wounds in the course of their treatment by a doekoen'.

This 2,000-year-old masticatory tradition has spawned a paraphernalia of ornamental implements to cater to its enjoyment. While these are now collectors' delights, the chewing ingredients are still vital offering items in temples or homes in many places. *Sirih jantung* (areca nuts and *sirih* leaves) and *nasi kuning* are offered to a Malay midwife on booking her for an expectant mother. In Malay courtship, the betel leaf signifies the girl; the areca nut, the boy. A girl accepts a proposal by agreeing to chew betel with her suitor. Hence a betel chewing box among the engagement or wedding gifts symbolizes tying the nuptial knot. Such rites are still observed in traditional Malaysian weddings.

5

Rice, the Tasty Grain

The height of the sky is determined by a maiden who, with her vigorous, rhythmic pounding of rice, pushes it upwards with the pestle.

(A northern Luzon myth)

RICE is so important a staple in South-East Asia that countless myths and legends, beliefs, customs, rituals, and proverbs have grown up around the region's rice-eating culture over the centuries. A Malay proverb warns that 'without rice, there is nothing doing' while a Vietnamese proverb states that 'though the scholar may precede the peasant, when the rice runs out, it is the peasant who precedes the scholar'. However, fundamental as rice is to the cultures of South-East Asia and widespread though its cultivation may be throughout the region, it is by no means an easy crop to grow. Indeed, the picturesque and seemingly idyllic paddy field landscape (Colour Plate 11) belies the back-breaking labour needed to grow the well-loved grain. A rice-planting song from the Philippines, taught in missionary schools throughout the region, relates the toil and the reward that are shared by all rice growers:

Planting rice is never fun, Bent from morn till set of sun,
Cannot stand nor cannot sit, Cannot rest for a little bit.
When the early sunbeams break, You will wonder as you awake,
In what muddy neighbourhood, There is work and the pleasant food.

(Gladys Zabilka, *Customs and Culture of the Philippines*, 1963)

South-East Asian rice growers believe that rice is a grain with a soul. In all the cultures, rice is life—*mertha* in Bali, from the Sanskrit *amertha*—and a gift from the gods. A good harvest symbolizes being blessed, so the need arises to perpetuate this blessing through planting ceremonies, harvest celebrations, and thanksgiving

festivals. In Indonesia, rice is the offspring of Dewi Sri, the Goddess of Prosperity and Fertility. Thailand's Mae Posop, Burma's Chaba Yendai, the Malaysian Semangat Padi, and the rice guardian Phi of Laos and Vietnam are the same rice spirit who is catered to with respect, tender care, and very similar thanksgiving ceremonies and rituals. Oblations invariably include glutinous rice, eggs, coconut, sugar-cane, betel, and areca nuts, laid on the ground which has been sprinkled with holy water. Numerous taboos govern the life of the rice farmer as the rice grows and ripens.

The Thai and the Malays harvest their rice by individual stalks using a small knife blade concealed in a palm-sized wooden handle so as not to frighten the gentle rice spirit. Called *ani ani* or *anggapan* in Bali, it is held between the index and middle fingers of the right hand with a little crossbar in the palm. Cambodian farmers use a larger sickle with its handle carved into the tail of a mythical bird called *humpsa*, or in the shape of a dragon, for good luck. Although the new strains of commercial paddy are machine-harvested and milled in more industrialized areas in Malaysia, Indonesia, and the Philippines, much of it is still traditionally done by each community's helping hands. Husking rice with a wooden mortar and pestle, and winnowing are still seen in more rural rice-growing villages where rice harvest is the happiest time (Plates 12 and 13). Weddings and celebration feasts usually take place in conjunction with it. Respect due to the grain cannot be more strongly stressed than by the fact that it is stored in the rafters, the most honourable place in the house, where offerings to the ancestors and auspicious spirits are made.

Whether it is the lowland wet paddy or the tribal hill paddy, rice is the preferred South-East Asian staple, although remote kampong dwellers put up with maize, sago, or cassava whenever the harvest is slow or poor. In native social reckoning, rice eaters have a higher status than corn and root crop eaters. Rice is the first item to be moved into a new house in the Philippines to symbolize the continuity of supply and prosperity. A South-East Asian infant's first solid food is rice. A universal admonition to children who leave untidy rice grains in their plate or bowl is that their future spouse will be pock-marked. Spilled rice is never swept up with a broom

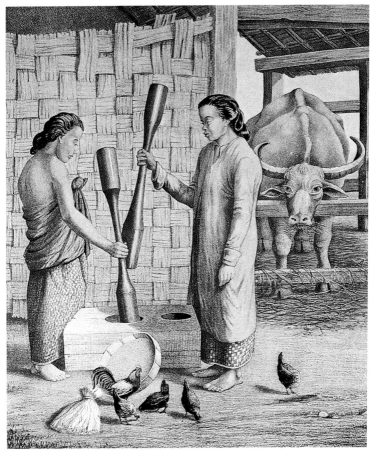

12. Javanese women husking rice with the wooden mortar and pestle; lithograph by C. W. Mieling after A. van Pers, from *Nederlandsch Oost-Indische Typen*, The Hague, 1853–62.

but picked up grain by grain. When a Thai has to remark on any cooked rice that has gone bad, he first murmurs an apology to Mae Posop.

Rice is also an important food used in ceremonial offerings, as seen in the enormous Balinese *nasi tumpeng* (conical rice cakes) and

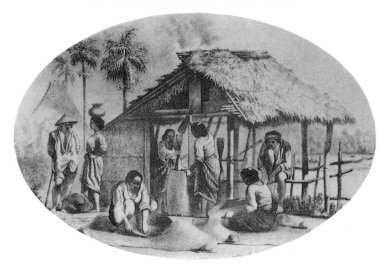

13. Processing newly harvested rice in the Philippines; lithograph, 1859. (Courtesy of Ayala Museum Library)

jaja (biscuits made of rice paste), as well as in the Malaysian *pokok nasi* (rice cakes offered at weddings). In Sarawak, in a Dayak ceremony known as *mireng*, rice in various forms is offered to the spirits residing high in the rafters (Plate 14).

In any South-East Asian language, to 'eat rice' means to have a meal, and to 'cook rice' is to prepare a meal. The ubiquitous greeting 'Have you eaten rice?' shows a warm concern for friends who meet. Rice is the central staff in a meal with fish, vegetable, or meat dishes and sauce mixtures, all of which encompass the five tastes—salty, sweet, sour, bitter, and pungent. These accompaniments are known as *kap khao* ('with rice') in Thai, *lauk* or *kuah* in Malay, and *ulam* in the Philippines. The Chinese word 'shung' is phonetically rooted in 'send', as in sending or accompanying the rice down. It is inconceivable for a South-East Asian to imagine, let alone eat, a meal of savoury courses without any rice, or vice versa.

Rijstafel, the Dutch concoction of a 'rice table', is said to be modelled on the ordinary Indonesian rice meal. Its opulence and

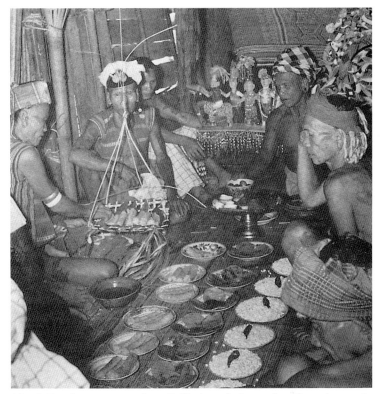

14. A Dayak ceremony where fluffy rice, glutinous rice, rice cakes, *tuak*,
 sirih, tobacco, and salt are offered to the spirits in the rafters;
 photograph by Hedda Morrison. (Courtesy of Division of Rare and
 Manuscript Collections, Carl A. Kroch Library, Cornell University)

ostentation, however, was infamous when compared with the
modest, indigenous, daily fare of plain rice with salted fish or *cili
sambal*. *Rijstafel* is a 'Dutch lunch that takes twenty-three men and
a boy to serve', and is described by Augusta de Wit as 'that
supreme mystery, celebrated at noon.... Here is indeed, "un
étouffement nouveau." All things work together for bewilder-
ment.' The central most important and prominent item is the
'mountain' of fluffy white rice. Each guest, with two plates in

hand, fills one with as much as he wants of rice and the unending servings of curries, *sambal*, meat, and vegetables. The amount is expected to overflow into the second plate. The long table groans 'under its dozens of rice-bowls, scores of dishes of fowls and fish and hundreds of sambal-saucers'. The sumptuousness of the lunch has inspired many visitors to the colony to pen long passages of its virtue and vice, for, following it was the natural sequence of the Dutch siesta. The Indonesian *slamatan*, the religious feast where innumerable elaborate dishes are served as they never are in the ordinary meal, is also claimed as the inspiration for this food display. *Rijstafel* itself, however, is sometimes credited as the precursor of today's humbler buffet-lunch table served in classy hotel restaurants. The dazzle of the first *rijstafel*, though, spoke of untold wealth and power.

In Malay, *padi* is rice in the field, *beras* is husked rice, and *nasi* is cooked rice. While the long-grain rice, *Oryza sativa*, cooks into fluffy, separate grains of *nasi*, the glutinous rice, *O. gelatinosa*, is often steamed with coconut milk into sticky, shiny, and filling festive or snack foods, eaten in small amounts. A harvest celebration beverage enjoyed by all rice farmers is a home-brewed 'whisky', made by fermenting cooked glutinous rice with a dry, spiced yeast called *ragi*. This is stored in an earthen jar for a month to exude a clear, sweet alcohol. The Sarawak Dayak's distilled rice *tuak*, the Sabah Kadazan's *hiing*, and the Laotian *uk* are intoxicating harvest rice wines drunk straight from the jar with a bamboo straw (Plate 15). The Malay *tapai* is glutinous rice fermented with *ragi* for two days, made for the new year and other festivals. Just as it turns sharp and smells faintly alcoholic, it is scooped into a banana or rubber leaf, folded into a little tent shape, and sealed with a satay stick. Ordinary cooked rice and tapioca are similarly fermented and named, and sold daily as a sweet.

No waste is allowed of any food, but with rice, even the crust at the bottom of the pot is savoured as it is, or made into a snack, sweetened with caramelized sugar. The water in which rice is rinsed the second time is used like cornstarch water in thickening a dish, and as the broth for the Filipino *sinigang*, a substantial tamarind-based seafood or meat and vegetable soup. The Chinese

15. A Murut man drinking rice wine from a Chinese
jar in a longhouse on the Padas River, Sabah;
photograph by Hedda Morrison. (Courtesy of
Division of Rare and Manuscript Collections,
Carl A. Kroch Library, Cornell University)

use it to boil freshly harvested bamboo shoots to rid them of
hydrocyanide, a volatile poison. Water in which rice has been
boiled before steaming is drunk to allay fever, or to ease and
cleanse a sated, greasy, and 'overworked' digestive system.

Every South-East Asian child old enough to handle the stove

45

fire knows at least the basics of cooking rice. Although the Japanese rice cooker has become a modern kitchen appliance since the 1960s, many still cook rice in a pot over an open gas or charcoal fire. One method is to boil it until all the water is absorbed and then leave it to steam over a slow fire. Another is to boil and drain the rice water (for drinking or cooking) and then steam the rice in a conical bamboo container called *kukusan* in Indonesia, set over a pot, the *dandang*. This is also common in Laos and Cambodia. Another method, used throughout the region, is to line a thin-walled fresh bamboo culm with banana leaves and fill it with rice (glutinous for festive occasions) and coconut milk, and 'smoke-roast' it over an open ground fire for a few hours. Called *lemang*, these are split open and sliced into rounds and served with various dishes.

Rice is eaten at least twice a day, mainly at lunch and dinner, and three times in areas where bread or cereal has not replaced it at breakfast. (It is estimated that the average South-East Asian eats at least half a pound of *beras* a day.) Steamed glutinous rice, or steamed and pan-fried rice flour cakes with a cup of coffee, is a quick breakfast for some, often bought from itinerant vendors or market-places. Leftover rice, strengthened with eggs, meat, chillies, and soya or fish sauce, is a favourite breakfast in the Philippines. Overnight rice is made into a simple rice soup in a Thai breakfast, eaten with sour and salty condiments. Substantial rice porridge with meat, fish, or liver and egg, mainly a Chinese repast, is one of many midnight extravaganzas available in all-night bazaars and food stalls in Malaysian towns. *Nasi lemak*, now served in restaurants with rich curries and accompaniments, is a traditional Malay breakfast rice cooked with coconut milk and eaten with *ikan bilis*, salted fish, hard-boiled eggs, fried peanuts, cucumber, and *sambal belacan*.

Rice meals at lunch are similar to those eaten at dinner in most cases. Many also eat rice in the form of rice noodles fried or quickly cooked with blanched seafood, vegetables, or meat. At dinner, rice is often more substantially served, with all the affordable fish, vegetables, meat, and sauces to send it down. For many, this is the main meal of the day, eaten between five and six in the evening.

6
Food from the Garden

The larger number [of indigenous fruits] grow wild, and the rest are planted in a careless, irregular manner about their villages.

(William Marsden, *The History of Sumatra*, 1783)

LONG-STEMMED leafy cabbages, mustard greens, spinach, gourds, onions and the leek family, legumes, white radish, egg plants, cowpeas, and more were introduced into the region and naturalized through the early Chinese and Indians. The Spanish and Portuguese added bumper crops from South America and Africa, which, like the chilli, potato, tomato, okra, and many roots and fruits, have been so incorporated into the native food habit that their origin is no longer clear. Many temperate vegetables like Chinese cabbages, carrots, iceberg lettuce, and broccoli are cultivated in higher elevation areas, while others like mushrooms, berries, and asparagus are sometimes collected from the cooler mountain bushes. Many more tropical, indigenous, semi-wild fruits and vegetables are enjoyed from the family plots, which are cultivated with various products for the ever-increasing local demand.

Vegetables

Whether as a necessary part of a balanced meal, or as an economical bulk, vegetables are always cooked into some satisfying *lauk* (Colour Plate 12). They are stir-fried with garlic and onion, simmered in water or thin coconut milk, or richly dressed into curries. Vegetable soups are a substantial part of any meal, made with almost any vegetable or gourd, and some meat. This may be more prevalent in the mainland, but some form of vegetable soup is always eaten for moisture and nutrients to 'send' the rice down. Besides fresh herbs, many vegetables are eaten raw, while many

unripe fruits are cooked, like jackfruit and papaya. (Sugar-cane is a commercial food crop, eaten as a 'cooling' snack and used in sweetening braised or stewed meat or seafood.) Various mainland salads are of vegetables and fruits such as papaya, mango, and star fruit. When combined with cooked meat or seafood, and dressed with chilli, lime juice, and fish sauce, they make a substantial meal. A stringent traditional Malay rice 'salad' meal, *ulam*, eaten for a change to the system, consists of raw or blanched green vegetables and long beans mixed with cooked rice, toasted coconut, and pounded *sambal belacan*. Indeed, the coconut and the chilli are among the most versatile of South-East Asian food plants. The Malaysian *rojak* is a salad of fruit and blanched vegetables—such as *jicama* or yam bean, pineapple, mango, *kangkong*, bean sprouts, deep-fried bean curd—dressed in a sweet and chilli-hot, thick prawn sauce, and ground peanuts. The Indonesian *gado gado* may include similar blanched vegetables and white cabbage, potato, and deep-fried *tempe*, all to be dipped in a sweet, chilli peanut sauce (similar to satay sauce).

Sweet potato, cassava or tapioca (*ubi kayu*) (Plate 16a), and maize are staple substitutes in some places, but they are favoured more as savoury foods, as steamed sweetmeats, or in sweet coconut milk soups. The tender leaf shoots of taro yam, sweet potato, and tapioca, eaten to cleanse the digestive tract, are made into light, tasty dishes. The white crunchy *jicama* is shredded and stewed with meat and prawns, which is also used as a filling for the Chinese spring roll, *popiah* (see Chapter 2).

Many indigenous vegetables and fruits cultivated for the market are easily found in the backyard, which supports the 'pick and cook' habit of South-East Asians with an assiduous quest for the freshest food ingredients. A common kampong vegetable is the *petai* (Plate 16b), a legume with strong garlic odour pods. It is often eaten raw as it is believed to be good for cleansing the body's system. The *kangkong* (Convolvulaceae), a semi-aquatic spinach of the Morning Glory family, is a perennial that trails prolifically in ponds, paddy fields, or gardens. It is the most economical vegetable and the most commonly eaten in the whole region. The Chinese consider it a 'cooling' vegetable, and often fire it up in the wok

16. Common vegetables found in the kampong: (a) *ubi kayu*, (b) *petai*, (c) *paku*, and (d) *jantung*.

with a generous dose of oil and chillies. Another backyard semi-wild vegetable is the dark green, bush-like sweet *cekur manis* or *sayur manis* (*Sauropus androgynus*). The leaves are shredded and simmered with sweet potato in coconut milk, or stir-fried with eggs. This has been cultivated in the Malaysian state of Sabah into miniature bushes so that the whole tender plant can be eaten.

The *paku* fern (Plate 16c), curly headed and crunchy, is one of the many semi-jungle leafy greens gathered by native peoples and sold in village markets. Bamboo shoots and banana shoots are harvested after the monsoon rain by smothering them with earth or boxes to keep them pale and tender. The core of the banana trunk, said to prevent blood vessels from clogging, is a healthy food to the Burmese. Its tender inner concentrics—basically the leaf overlappings that form the trunk—are cut in cross-sections, soaked in water, and blanched for a salad. It is an indispensable item in the Burmese *mohinga*—rice noodles in a rich, spicy fish gravy cooked in the elaborate Burmese style—reputed to be the favourite food of Burmese kings.

Blossoms and leaves of odoriferous plants and herbs are added to well-spiced dishes for extra fragrance and as a garnish. *Bunga jantung* (Plate 16d), the yellow male flowers inside the purple flowerhead of the fruited banana bunch, the bitter papaya flowers, and durian or jackfruit flowers are all curry ingredients. *Bunga kantan*, the beautiful long, pink tender bud of a ginger species (torch ginger), is eaten as a vegetable or shredded to flavour a salad (such as *rojak*). The Kaffir lime leaves (see Chapter 3), Indian curry leaf (*Murraya koenigii*), Malay *daun kesum* or *laksa* leaf, *daun salam* (bay leaf), and *daun selasih* (sweet basil) are common herbs that give an aroma to curries and rice. Coriander leaves, mint, sweet basil, borage, and dill of the milder climes are used more in mainland garnishes, together with spring onion and celery. They give an immediate fragrance of green freshness to the food which also wakes up the appetite. The long *pandanus* or screw pine leaf has a new-rice fragrance that imparts a powdery aroma to special rice dishes, meat, and cakes, and it is also used in Malay pot-pourris. Certain species are medicinal, while others are woven into mats and food containers. The broad-bladed ones are used to wrap glutinous rice and

spicy meat filling into pyramid-shaped rice dumplings called *kuih zhang* in Straits Chinese cooking.

Fruits

Fresh fruits in season are so abundant that they are eaten in salads, cooked dishes, or pickles besides being snacked on all day, so that it is not strictly a tradition to eat them to end a meal. Yet when a 'dessert' is called for, it is usually fruits that are served, mainly to aid digestion. Sweet cakes or puddings as modern desserts are a legacy of European urban lifestyle in South-East Asia. The wide range of rice and coconut based cakes and bakery snacks are eaten more often in between meals than as a completion of one.

As snacks, fruits are not always eaten plain. Pineapple is rubbed with salt to 'sweat' out its sweet juice and neutralize its acidic sting on the tongue and stomach. The Thai spread it with chilli and *belacan* paste to counter its 'steely' sharpness. Star fruit (*Averrhoa carambola*) and sour mango are marinated in sugar and dark soya sauce, and guava is dipped into plain or sour plum-flavoured salt. A squeeze of lime juice often accompanies a slice of papaya to contrast its 'milky' taste. Overripe pineapples are made into pineapple jam, and unripe papayas are pickled as *atchara* in the Philippines. The colourful festive *acar cili* in Sarawak is sun-dried shredded papaya stuffed into whole red chillies and bottled in a spicy turmeric and sugar-sweet, vinegar sauce. The Filipino *halang halang* is papaya and chicken in coconut milk.

Fruit as a dessert is invariably served cut up neatly in its own pattern to make it attractive and easy to eat with the hand. A regular example is the pineapple: its skin is removed and the embedded calyces of florets are carved out at a bias to the fruit. This gives it a spirally grooved effect, so that the slices, whether lengthwise or crosswise, always look 'carved'. Fruit and vegetable carving is the high point of Thai culinary art. Sizeable fruits and melons become beautiful baskets carved with ornamental sprays of flowers, containing their own cut-up fruit. In the artist's hand, pineapples are turned into wagons with golden wheels. Smaller fruits become roses, chrysanthemums, orchids, and leaves. A display of Thailand's

carved fruit is a joyful feast for the eyes as well. Frank Vincent (1874) in the nineteenth century wrote that the Thai artist 'can remove the kernels from all stone fruit, with such skill that when placed upon the table, the eye fails to discover from its external appearance, that the natural condition of the fruit has been in any way altered'. With the abundance of fruits and their use as temple offerings, a love for beauty, and the need to present impressive banquet fruit platters, the Thais have developed fruit carving into an art that highly complements their cooking. Yet even the simple fruit and vegetable vendors and cut-fruit sellers in the whole region tend to show artistic inclination in the decorative display of their wares, which no doubt attracts buyers for the fruits as well as expresses their beauty in profusion.

The native tropical fruits of South-East Asia, however, are said to be at their best when eaten rather unceremoniously by peeling the skin, though many are also made into tempting sweetmeats to go with tea and coffee. The generous perennial banana plant, *pisang*, native to Malaysian soil, has been called 'the tree that yielded her fruit every month'. Once it fruits, it is spent and must be felled, thus inviting the Malay proverb, 'tidak akan pisang berbuah dua kali', meaning 'once bitten twice shy'. The palm-like trunk yields not only vegetable and fruit but huge sheets of leaves and dry sheaths, which have been used for centuries as nature's manufactured food containers, wrappers, and dining 'plates'. While many delicious species are eaten from the skin, the foot-long *pisang tanduk* is often sliced and steamed or made into banana chips, similar to potato chips. The starchy, sweet *pisang rajah* is fried whole in batter as a Malay snack called *pisang goreng*.

The citrus fruit is a South-East Asian native that has been naturalized in warmer parts of America into the various golden oranges. In its native state it is called the 'green' orange, as it remains green on ripening. Many species are easier to peel than to cut as the fragrant skin is thin. The grapefruit so popular in the Western breakfast was a botanical graft of the tropical pomelo and orange in the mid-nineteenth century.

Duku, langsat (Plate 17), and rambutan are smaller seasonal fruits borne in clusters with translucent sweet flesh and bitter seeds. The

17. *Langsat*, fruits and leaves; engraving, from William Marsden, *The History of Sumatra*, London, 1783.

hairy rambutan, a less evolved species of the Chinese litchi and *longan* family, has been so well grafted that many varieties are sweet, meaty, and almost seedless—a sugary snack in season.

Mangosteen, durian, and rambutan (Colour Plate 13) share the same seasons, at the middle and end of the year. While the durian has a world-wide reputation as the 'king of fruit', the mangosteen is praised as 'the queen of fruit' and 'the prize of the Indies'. The mangosteen's texture is 'so delicate that it melts in the mouth like ice-cream', and its flavour is 'indescribably delicious'.

Of the strong-smelling fruit, none has been as indomitable as

the spiky durian. Native to Borneo, the durian has had its share of admirers and detractors from home and abroad, and its own store of tales of financial woe and insatiable 'partying' when the king of fruit is in season. Most people desire rather than detest it, as its encompassing taste of garlic, onion, cream, custard, and 'something rotten' clings to the memory and creates a craving once it is tasted. Alfred Russel Wallace in *The Malay Archipelago* advised that 'the only way to eat Durians in perfection is to get them as they fall', as the smell 'is then less overpowering'. Christopher Borri (1583–1632), an Italian priest in seventeenth-century Vietnam, is said to have remarked that the cook must be 'God himself, who had produced that fruit' (Savage, 1984). In Borneo's Dayak cuisine, half-ripe durians are cooked in curry, like jackfruit, or steamed with sugar to make a sweet. Ripe durians from a big harvest are made into *tempoyak* and mild-flavoured durian cakes. Durian has also become an accepted flavour in commercial ice-cream. The Thai glutinous rice with durian and coconut milk is commonly eaten elsewhere in the region. There is a belief that durian with its high potassium content is good for reducing lymphatic swelling.

In the breadfruit family (Artocarpus), the jackfruit or *nangka* and the *cempedak* are both redolent of the durian, and are favoured over the milder breadfruit. There are great variations in cooking unripe and tasteless jackfruit into sweet, creamy curries. The Indonesian *gudeg* is an irresistible dish of jackfruit simmered with a whole cast of basic ingredients, coconut milk, and chicken. Boiled or roasted jackfruit or *cempedak* seeds, nutty and powdery, are deep-fried in batter for a delicious snack. The jackfruit tree is known for its hefty fruits, some of which weigh up to 35 kilos each. It is said that the tree bears its fruit from a footstalk on its main branch when it is young, from its main trunk at middle age, and from near its main root at old age (Colour Plate 14). The last, resting on the tree's 'ankle', is supposed to be the tastiest.

7
The Market

One might go on indefinitely describing the incidents of a village bazaar, and indeed it would be difficult to convey any adequate impression of a scene in which were combined brilliant colour, interesting faces, strange occupations, bustle and movement in bewildering confusion.

(R. Talbot Kelly, *Burma: Painted and Described*, 1905)

As fascinating as any sightseeing in South-East Asia are the market-places that provide the local people with daily fresh food, house-hold wares, and other knick-knacks. In the centuries of trade in the region, the market-places of coastal towns and cities have been inter-regional trading centres, as much as the inner village markets have been the centres for the exchange of farmers' produce and jungle products for goods from the towns and cities (Colour Plate 15). Even as modern superstores have sprung up in the urban areas since the 1960s, the bazaar, or *pasar* in Malay, has maintained its standing as a thronging 'supermarket'.

The day's business begins with the smells and colours of fresh vegetables, fruits, fish, and meat: the noise of preparation, the aroma of cooked food, and the jostling of crowds haggling, bar-gaining, and bartering, 'from the savage hunter and gatherer in the jungles to the despotic monarchs in the cities'. In some daily markets, businesses begin with the dawn. Before noon, fresh and choice food or goods are sold out, especially on festivals and reli-gious days when the place is indescribably congested and the prices highly inflated.

In the mainland, wherever rivers, canals, and lakes provide a major means of communication, daily marketing is also conducted on these waterways. Long-tailed boats, laden with fresh fruits, vegetables, or dried goods, are paddled by women who usually own the orchards and gardens of their produce. Those with a

hawker business on board sit amidst neatly arranged prepared food and crockery and cook the dishes instantly for customers on the bank or on another boat. The bustling, colourful sights and strange calls of their trades in these floating markets are a tourist attraction in the major cities of the mainland, especially in Thailand.

Roofed-over but open-aired and permanently built *pasar tani* or farmers' markets in towns and cities are also known as 'wet markets' to English speakers (Plate 18). It is a description befitting those with perpetually wet floors, a result of watering the vegetables and icing the fish, and of scaling and gutting them. Where poultry are slaughtered on request, their cleaning and dressing add to the heat, smell, humidity, and complexity.

Yet the market-place provides a fascinating study of the multi-cultural society of South-East Asia. Each market tells of the preferences of a particular group of people. The display of certain goods reflects the predominance of certain cultures in the vicinity. In

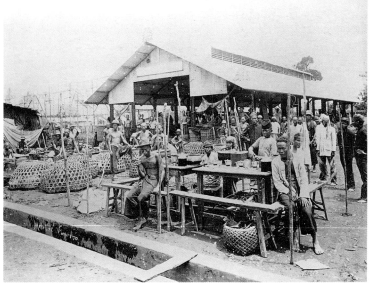

18. A wet market in Singapore in the late nineteenth century. (Antiques of the Orient, Singapore)

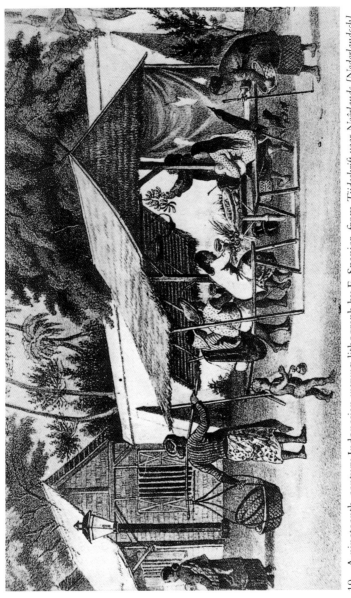

19. A nineteenth-century Indonesian *warung*; lithograph by E. Spanier, from *Tijdschrift voor Neêrlands [Nederlandsch] Indie*, Batavia, Zalt-Bommel, 1853.

general, vendors with similar wares are grouped in the same sections, much like a supermarket. Fresh fish and poultry markets are sited near an entrance for quick loading and unloading of the day's catch, sometimes simply on the roadside, quayside, or river bank. In the meat stalls, the Muslims sell their beef and mutton a vast distance from the pork butchers. Vegetable vendors always have a larger department for their dazzling variety of produce. Here too are the stalls for Indian spices, bean curd, preserved food, grated coconut, fresh fruits, and basic ingredients. There is always a bright and fragrant section of gay, floral display, which 'would be the envy of a Parisian', as Carl Bock wrote of the Chiang Mai market in 1884 in *Temples and Elephants*. Flowers and fruits appeal not only as offerings to deities but as gifts to human beings as well.

In the market vicinity dwell shops that sell a variety of goods, including hardware, kitchen appliances, and dinnerware, not unlike the shops observed by R. Talbot Kelly (1905) in Burma, which boast a 'curious assortment of wares: Burmese silk, Manchester cotton goods, Sheffield hardware, and school books and pencils from Germany'. Other shops sell food for breakfast and lunch, as well as snacks of sweetmeats and cakes all day long. Food stalls, called *warung* in Indonesia (Plate 19), can be mobile pushcarts or permanently sited stalls, or coffee-shops. Such food stalls or shops selling ready-to-serve rice meals are called *turo turo*—'point point'—in the Philippines, as the customers point to the types of cooked food they want and the vendor dishes them out.

In centuries past, itinerant vendors (Plate 20) would cart their foodstuffs and crockery in baskets slung from a long wooden pole balanced over the shoulders, like a scale. They would hawk from door to door, especially in the cities and big towns, announcing their menus in distinctive rhymes or singsong cries. The hawker's offerings frequently comprise those requiring complex preparation of ingredients, worthy of home labour only at feast time. Examples are the roasted meats, assorted buns, rice cakes, noodle snacks, and satay, which are prepared for instant cooking or warming up 'while you wait'.

A night attraction of the urban areas is the *pasar malam*—night markets that light up in the streets and lanes at dusk and that last till

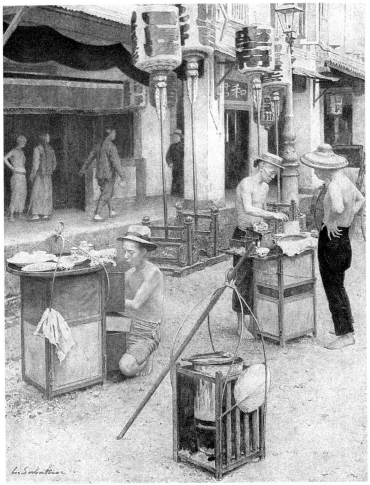

20. Itinerant vendors hawking cooked food from door to door in late nineteenth–century Singapore. (Antiques of the Orient, Singapore)

the late hours. Besides dinner fare, snacks, and fun food, these markets feature a great variety of manufactured goods and crafts, from needle and thread to religious wares and electrical appliances.

As on the island of Bali, the selling is mainly done by women. Throughout the centuries, South-East Asian women have worked out of the home, manning both business and family life. Chou Ta-kuan made this observation as early as the thirteenth century in *The Customs of Cambodia* (1987): 'In Cambodia it is the women who took charge of the trade. For this reason a Chinese, arriving in the country, loses no time in getting himself a mate, for he will find her commercial instinct a great asset.' Even in Vietnam, where the Confucian patriarchal system has held sway since the fifteenth century, women have always been actively involved in market businesses. The Burmese and Thai take pride in their womenfolk's business talent.

Munshi Abdullah, travelling in Kelantan and Trengganu in 1830, saw 'women hawkers bring their garden produce in baskets on their heads to a market from sunset to night fall'. He further commented that such markets 'are common in Java and among the Minangkabaus'. This kind of native market, seen all over the region in open grounds and held daily, weekly, or on weekends, caters to vendors and buyers without a middleman. Much of the business is still done by bartering. In the Malaysian states of Sabah and Sarawak, such markets are known as *tamu*, meaning 'a meeting place'. *Tamu* originated in Sabah in the early 1900s, when the British North Borneo Chartered Company tried to gather the natives from their various remote districts and kampongs on Sundays to trade and to socialize. Its main aim then was to aid the administration in disseminating advice, counsel, and education to the indigenous people without having officers trek into the jungle looking for the dispersed tribes.

Tamu are now established business centres in places where native people have become town dwellers, with jungle farms nearby. Their roofed-over buildings are structurally similar to those of the wet markets, though characteristically different. Native vendors sell jungle or backyard produce, in particular, the hill paddy, and stay till sunset or later. Farmers come in on foot with goods in

bamboo or rattan woven baskets—the native backpack. In Sabah, men ride in on buffaloes known as *kerbau* or on ponies, like cowboys, while their wives may ride with them or come in by foot with more goods. Dry and fresh goods like areca nuts in bunches, banana stems, fern vegetables, bamboo shoots, sections of bamboo culms for *lemang*, honey and beeswax in bamboo tubes, tobacco leaves, home-made *belacan*, and bottles of fish paste are spread on clean mats on the floor. The vendors sit beside their goods, chewing betel quids or smoking tobacco and hand-rolled cigarettes, and exchanging news and gossip. Here are found jungle fowls, or chickens that scratch the ground for a lean living, and are void of the growth hormone of 'farmed' chickens. Small jungle animals, birds, and freshwater fish are stacked in one section, with fighting cocks a main attraction for many. Another large section, spilling on to the roadside with colourful umbrellas as sheds, sell handicrafts like woven mats, baskets, hats, textiles, and other typical village crafts and utility goods.

8
The Kitchen

Yet with this primitive equipment miracles in the way of cooking
were performed by the better cooks.

(Nancy Madoc, 'The Mem', in Charles Allen, *Tales from the South
China Seas*, 1983)

THE traditional kitchen, whether large or small, is always situated
at the back of the house (Colour Plate 16; Plate 21). It can be
a simple lean-to building, or a shed, open-sided and airy, with a
thatched roof, like those seen in Burmese towns and villages. In
a typical Malay house structure, the veranda in the front and the
kitchen at the back are always at a lower level than the middle sec-
tion that contains the sleeping rooms. One explanation in the
mainland is that it is an indignity to sleep 'under other people espe-
cially under women'. In old-fashioned urban bungalows, the
kitchen is a separate building with a short covered passage leading
to it from the back of the main house. The general idea is to have
the kitchen with its smell, sound, heat, grease, and water removed
a few steps away from the sleeping and living quarters.

A similar concept of the kitchen is held throughout the South-
East Asian countries: it is a workplace where the household begins
the day by cooking, perhaps only once, in some cases twice, food
for the whole day. Here may be eaten the simplest or plainest daily
meal, the privacy of which is only shared with one's closest friends
or with neighbours who visit. This is also where a household's
status can be gauged and sometimes found wanting. Mainly,
women friends are known to be received there, especially to help
with cooking food for celebrations. Hence it is commonly called
the 'women's area'. The Malays refer to the kitchen as a 'dirty and
wet' place.

The nineteenth-century Protestant missionary, Mary L. Cort,
described the Thai kitchen in *Siam: or The Heart of Further India*

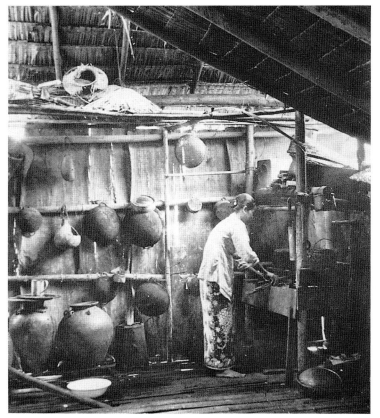

21. A simple Malay kitchen, with a low raised clay hearth; photograph by Hedda Morrison. (Courtesy of Division of Rare and Manuscript Collections, Carl A. Kroch Library, Cornell University)

(1886), as a 'dirty and dingy place', where clothes get soiled 'against black rice pot or come in contact with drying fish'. A typical Thai village kitchen, like many others in rural houses, is traditionally sited at a level below the other parts of the house, with wood burning stoves that smoke out everything in sight. Latticed flooring in the area near the stove, where food is prepared, serves to dispose of scraps to pigs or poultry below. A dry area under such

houses also stores firewood and discarded household goods and gadgets, making it, at times, a treasure ground for antique enthusiasts. Where water is not piped into the house, it is stored in separate earthen jars for cooking, washing, or drinking. Burmese Buddhists, in their charitable and merit-accumulating act, provide such jars of drinking water outside the house for any passers-by.

The richer households, with extended families and considerably more cooking and private entertainments, have larger and better-equipped kitchens, with large raised stoves and finer crockery to show. These kitchens are customarily offered for communal cooking for festive occasions, when the womenfolk cook the curries and rice, while the men slaughter the animals, pound ingredients, and grate coconut.

Most average urban houses in South-East Asia have furnished kitchens, with wall storage cabinets, counters, and modern appliances. It is not uncommon to have an adjacent kitchen to this, called the 'open' or outer or even 'dirty' kitchen, where deep-frying, grilling, roasting, and washing up are done. This dual kitchen may be an extension of the village kitchen, where dishes are washed and then drained on a large wooden latticed platform built into the wall outside, as in a Malay house. It may also be a legacy of the colonial days. Old colonial houses in many areas have a 'clean' kitchen in the house with baking appliances for European cooking, and a plainer kitchen in a separate building behind for the indigenous servant and her family.

Since South-East Asian culinary skills lie in steaming, boiling, deep-frying, stir-frying, and open-fire roasting, the simple kitchen appliances reflect these techniques. Stoves are often 'recessed into the floor'. In the thirteenth century, Chou Ta-kuan (1987) described how 'three stones are buried to form a hearth'. In the nineteenth century, Ernest Young (1898) gave us his version of a primitive stove: 'A wooden box is filled with earth, and a couple of bricks are placed thereon. The fire, which is of wood or charcoal, is laid between the bricks, and the pot, pan, or kettle is supported by them.' Nancy Madoc (1983) marvelled at the ingenious Malay oven which was 'frequently shaped out of the ubiquitous and

invaluable kerosene (paraffin) tin'. The Malay New Year sponge cakes in flower and animal moulded shape are 'baked' in covered brass moulds with charcoals placed over the lids and at the bottom. Modern and larger kampongs may have supplies of tanked gas that are used with raised stoves, but the ancient floor-level wood burning stoves are a norm in the kitchen culture of most rural districts. Raised stoves are generally low, about 2 feet (0.6 metre) in height, and are made of clay or brick. They can be wood or gas burning.

The traditional housewives work squatting on the floor, sometimes by the floor stove (Plate 22), or sitting at a low table to pick and cut the ingredients. This is kinder to the feet and the back than standing at a counter when a whole day has to be spent cooking for a special occasion. The tube-like batik sarong worn by the traditional women at home facilitates movements of squatting and stretching intermittently.

Many traditional kitchen utensils also require strength to handle them on the solid floor, for example, the deep granite mortar and pestle or *batu lesung*. Conventional cooks believe that this ancient gadget does a better job than electric blenders or millers, for, they bruise and crush ingredients like chillies, ginger, lemon grass, *belacan*, and candlenut to release their full flavour and oil, and to make them into a coarse or fine paste as required. In Thai kitchens where wooden mortars and pestles are also used, individual ones are kept for certain ingredients because wood retains smell. A shallow plate-like stoneware mortar and a wooden pestle—the *cobek* and *ulek ulek*—are used in Malay cooking to grind garlic or *belacan*, and mix ingredients for a dressing, or the *rojak* sauce. The Indian style *batu giling*, a stone slab with a large long stone roller to match, is essential for an even finer job of crushing and grinding spices and ingredients. These stone gadgets sometimes double as knife sharpeners. Knives are chiefly the versatile Chinese cleavers, which go together with the round tree-block cutting board in most households for all chopping and mincing jobs. Another equipment in older kitchens is the hand grinder for coarsely or finely ground roasted peanuts and dried prawns for garnishes. It can even be used to grind coffee beans.

22. Cooking on a floor stove in a Javanese kitchen, from Augusta de
Wit, *Java: Facts and Fancies*, The Hague, W. P. van Stockum, 1912.

A rice-husking mill, hollowed out of a tree-trunk into a trough
and used with an equally heavy-duty pestle (sometimes made to be
operated by foot), is seen in rural backyards where rice is husked
daily. The husking job does not require brute strength; rather, it is
made easy with a certain rhythm, and is usually done by women-
folk. The manually operated stone miller, or *mo* in Laos, was
another common 'appliance' in kitchens when cakes were made
from freshly milled wet rice flour. This has become redundant

where milled flour is supplied by local electric mills or imports.

The Chinese cast-iron wok—the Malay *kuali*, Indian *kawali*, or Indonesian *wajan*—is widely used for all kinds of frying and steaming. Its all-round sloping shape facilitates even heating while containing a spatter of oil. Steaming is done in Chinese bamboo or metal steamers, or by using pots and pans. Earthen pots are the most regularly used and preferred cooking utensils in many homes, especially for rice, and for tamarind or lime-based soups. Certain pots are kept specially for fish, meat, or vegetable cooking to keep their spicing flavour distinct. Some villages in the mainland have for centuries specialized in firing unglazed clay or earthen pots for cooking, and jars for fermenting fish and storing grains, wine, or water. In the urban areas, particularly in the countries of the archipelago, more stainless steel and aluminium utensils are used in modern kitchens for the sweeter curries. They are light, economical, and easily available commercially. In Mindanao, brassware like pots, pans, trays, water jars, cups, and even *kendi* are traditionally works of outstanding craftsmanship.

The manual coconut grater, as described in Chapter 4, has disappeared from the average kitchen. Its advantage lies in allowing the meticulous cook to grate more or less of the brown coconut skin, which contributes to the oiliness of the resulting dish and yields totally white, tender coconut meat for cakes and desserts.

One of the few pieces of furniture in a conventional kitchen is the 'food safe', or 'meat safe', for keeping dry snacks or food ingredients and leftover or cooked food overnight. The Burmese call it a 'cat safe'. In village kitchens where refrigeration has not arrived, buffalo skin is sun-dried for preservation, and pork is boiled and salted to keep almost like bacon for a week or two in these safes. When the refrigerator first arrived in the city kitchen of the late 1950s, it was used sparingly as a storage for cold drinks, desserts, and leftovers rather than for freezing bulk meat and vegetables. These were preferably bought in the market every morning, together with the many interesting breakfast items.

9
Meals and Etiquette

The Javans, except where respect to Europeans dictates a different practice, eat their meals off the ground. A mat kept for the purpose is laid on the floor, which when the meal is over, is again carefully rolled up, with the same regularity as the table-cloth in Europe.

(Thomas Stamford Raffles, *The History of Java*, 1817)

IN the mainland, with perhaps the exception of northern Vietnam, meals are generally eaten from low round tables no more than 18 inches (45 centimetres) high, with the diners sitting on the floor around it (Colour Plate 17; Plate 23). In the archipelago, meals are eaten from clean mats on the floor in the kitchen or an adjoining room. (As shoes are left outside the house, floors in the homes are never deemed to be soiled.) In either case, an array of four or five dishes, with dry ones balanced by curry gravy or soup, is laid out in various bowls and saucers on a tray or on the floor to be served all at once. The diners with rice on a plate or a banana leaf help themselves, dipping the food into hot sauces and pungent condiments as required. The men sit in the *bersilah* position (that is, with their legs tucked under in front), while the ladies sit in the *bertimpoh* position (that is, with their legs tucked behind, on one side, to the right). Antonio Pigafetta described how his party sat with their legs 'drawn up like tailors' on bamboo mats in the Philippines, and in Brunei, they 'supped on the ground upon a palm mat'. Even as kitchen or dining tables are now used, many families still prefer to eat in the traditional manner at home.

Eating a rice meal with the right hand and from the banana leaf or any other large leaf or palm sheath is fundamental to all South-East Asians, perhaps a foundation laid early in Hindu times. Chopsticks are an alternative for food served in bowls, or for eating noodles, particularly in the mainland. The Malays use forks and spoons for public dining, and for eating noodles and soup dishes.

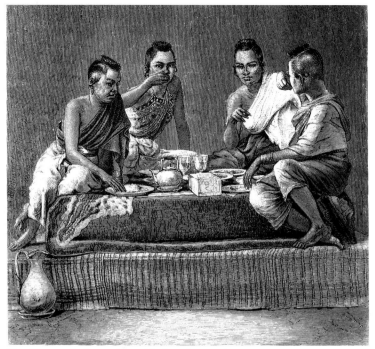

23. Siamese ladies eating with their hands, from Henri Mouhot, *Travels in the Central Parts of Indo-China, Cambodia and Laos*, London, John Murray, 1864.

Emily Innes, wife of another British district officer, and the author of *The Chersonese with the Gilding Off*, recounted that once, when entertaining a Malay chief (Raja Samar) at a dinner, he 'apologised gracefully for eating with his fingers', for he did not know 'the history of this fork. It has been on a hundred, perhaps a thousand mouths.' The Malays have jocularly named the right hand Adam's fork and spoon in reference to its being the first natural tableware. Eating with the hand is not a 'finger licking' concept: its etiquette and rules of hygiene might have slipped spurious observations of early travellers in Thailand who wrote, 'They eat with their fingers, very few having so much even as a spoon.'

Hands are always washed before approaching the meal table. Just before the first mouthful, the right hand is lightly rinsed again from a small basin or teapot-shaped vessel, called *priok* in Malay, which sits over a receptacle for the used water. This ritual facilitates the handling of the rice, much like what the Japanese cook does when making rice balls or sushi. A little *lauk* is taken at a time from the dishes, and mixed with the rice on the edge of the plate on the diner's side. This is delivered to the mouth in one swift push of the thumb. The rice is worked on outwards from there, so the remaining rice looks tidy and still 'white'. At the end of the meal, the diner would have deftly used only the thumb and three fingers, and not beyond the second joints, so that he only needs to rinse these lightly from a *priok* or in a finger bowl. This cleansing is a ritual at feasts and public dining to rinse off smell and debris. Hands are more thoroughly washed at home after dinner.

In accepting a choice of Western utensils in lieu of the hand, South-East Asians have eschewed the knife, which is not only unnecessary but is considered a weapon, and a sign of aggression, never to be wielded while eating. Finely cut, shaped, and well-cooked vegetables, meat, or fish in gravy are easily broken with the hand. This is, in fact, the best way to tackle any part of a chicken or to shred the well-stewed beef *rendang*.

As meals are cooked early in the day—traditionally, stoves are lit only once—they are eaten at room temperature, or even cold. Only the soup, which is preferably served warm or hot, and curry gravy are spooned with the unsoiled left hand which does not hand food to the mouth 'for reasons it would offend good taste to mention', as John Turnbull Thompson (1864) put it. The left hand also sometimes supports the *bertimpoh* sitting position. As a sign of courtesy, the left hand is never used for handing things around or giving things away in all South-East Asian etiquette. At a Malay royal feast in nineteenth-century Malaya, it was noted that bowls and saucers of prepared food and serving bowls and water were carried in gold and silver trays by servers with both hands held high over the right shoulder. Brass spittoons for bones and discarded bits were carried low in the left hand. Another example is the Malay etiquette for eating bananas. The fruit, held in the left hand, is

peeled by the right hand, which also breaks off the flesh and delivers it to the mouth.

The Vietnamese noticeably eat in the Chinese style, from rice bowls with chopsticks, and food is always eaten warm. However, the Vietnamese dining tables are generally low; many are no more than 2 feet (0.6 metre) high, with low stools, especially in the south.

Mealtime is an important occasion, not to be disrupted with too much conversation or discussion of serious matters and business. A meal is eaten not so much in silence as in a spirit of commensality. It is a custom to dine together whenever possible, rather than alone or away from people (as in the Balinese Hindu culture). However, family members with different working hours often eat whenever they want. In the Philippines' Dologon culture, eating a meal is receiving God's blessings. While Christians say grace, the Muslims have a quick silent prayer before partaking of food (Colour Plate 18). When a meal is eaten together, a hierarchy of 'age before beauty' applies at the start of the meal. The oldest person present takes the first handful to inaugurate the meal, after which further ceremony is dispensed with. A host invites a guest to begin, or he begins with a gesture for others to follow.

Drinks do not always accompany the meal except perhaps during festive times. Lukewarm or cooled boiled water is drunk after a meal, traditionally served from a *kendi*, a handleless water vessel held by its neck, and poured at arm's length from a height so that the mouth never touches the vessel's spout. It is thus not unhygienic to share a *kendi*, and it saves on washing up cups and glasses. *Kendi* for daily drinking purposes are usually made of unglazed earthenware, stoneware, and porcelain, while those with more symbolic and religious functions are made of brass, pewter, silver, and gold. Glasses for drinking (glass dishes for dining are also a favourite with the Malays) were later European introductions, especially in modern public dining, for serving carbonated beverages and thick, sugary, milky tea or coffee. Warm plain tea is drunk by some after the meal instead of water, especially where tea plantations abound in the mountain areas. But tea or coffee is generally drunk in the day as a 'pick-me-up', which can be as frequent as the English cup of tea.

The average South-East Asian dinner service consists of simple plates, saucers, and bowls of glass, porcelain, earthenware, or enamel supplied chiefly by China. Some simple folk utensils are made from coconut shell. Dishes are usually small, for portions of meat, fish, or vegetables, and are placed on a large round enamel or brass tray to be transported to the eating area. There it sits snugly over the low, round dining table or on the floor in the centre of the dining circle. Woven bamboo baskets are common dinnerware in the mainland where sticky rice is eaten. Round dining tables of the mainland countries are predominantly made of bamboo and rattan.

The richer households have better quality porcelain crockery from China and utensils of brass or silver of Indian or local craftsmanship. Some of these are used only on ceremonial or special occasions. This was particularly true of the Straits Chinese and Peranakans of the archipelago during the nineteenth century, when European influences on the urban lifestyle were strongest, with houses boasting large kitchens and showcases of finery. In wealthy families, beautiful silverware has always been treasured as part of the family heirlooms.

10

The Language of Food

A real chilli, seven fathoms under water, will still taste hot.

(Hla Pe, *Burmese Proverbs*, 1967)

BESIDES sharing many culinary habits, South-East Asians also share a host of similar sayings and proverbs, which Aristotle once likened to 'fragments of ancient wisdom preserved amid wrack and ruin for their brevity and aptness'. These 'words of wisdom' are uttered to decorate a story, to enliven a conversation or an exhortation, or to support an argument or a debate. The Burmese or Thais, with their Sanskrit and Buddhist foundations from the Indian and Chinese–Tibetan cultures and their native tendency to compose odes and verses, often draw upon age-old sayings to add strength and humour to their expressions. The Minangkabau people of Indonesia are said to have a knack for spicing their speeches with a few apt sayings to win the day in a banter or a contest of wit. Early Buddhist and later Islamic literary influences are also strong in the Malay Archipelago, where the people are no less responsive to song and music. The nineteenth-century Malay traveller-writer Munshi Abdullah, who was of Arab and Indian mixed descent, added considerably to the collection of Malay proverbs when he translated and adapted many Indian, Persian, and Hebrew sayings into the Malay language.

Many of the South-East Asian proverbs are used for making strong moral points, and the same sayings are often applicable to more than one situation or circumstance. In the rich store of local proverbs, food is a favourite theme, being constantly used to depict or to compare various aspects of life and behaviour, such as courtship, marriage, etiquette, humility, propriety, and even hypocrisy.

Naturally, rice is an important subject. The common Malay saying 'be like the *padi*—it bows low when laden with ripe grain; the *lalang* stands arrogant but has nothing to show for it' is an obvious exhortation to practise humility and to refrain from putting on airs

73

(Plate 24). 'Talking about spilled *tuak*' is equivalent to 'crying over spilled milk', while 'making flour without rice' is to undertake something without the requisite knowledge or capital. 'Rice that enters the spoon does not always enter the mouth' is the local rendition of the Western saying 'there's many a slip 'twixt the cup and the lip', implying that nothing is certain until it is actually obtained or fulfilled. 'If you plant grass, don't expect rice' is a blunt equivalent of 'you reap what you sow'.

That older is wiser is implied by the crisp Burmese aphorism 'he ate rice first', which is similar to the Chinese maxim 'I have eaten more salt than you have had rice', meaning 'I have seen more of life'. In the Philippines, the same idea is conveyed by a saying about the green lemon, which 'though repeatedly pressed, would not produce any juice'. The need to work hard to achieve success is expressed by the proverb 'do not wait for rice to be served up at your knees' (as you sit cross-legged), while propriety—doing things in the correct manner or proper order—is taught by the

24. A paddy plant bending under the weight of its grain in contrast to a sturdy *lalang* plant.

expression 'pound rice in a mortar, boil rice in a pot'. 'Eating from a big cauldron' is a jibe at grown children who are still dependent on their parents, while the saying 'when there is more meat, there is more rice' is an oblique reference to sycophants. 'Where else is gravy poured but on rice?' is applied to the normal course of events, while 'steam coming out of cold cooked rice' is used of an unlikely prospect, such as expecting a miser to part with his money. Finally, the valued trait of self-reliance is taught by recourse to the terse saying 'don't hope for someone's rice', which comes from a Malay *pantun*:

Don't hope for someone's rice
It may be harvested, again it may not,
It may vanish over yonder.
Don't hope for someone's sweetheart
They may part, again they may not,
Their love may even grow fonder.

Seafood, particularly fish, also features prominently in many local sayings. The Indonesian proverb 'a water pot full of fish is ruined by cheap *sere*' is used of someone whose otherwise exemplary character is marred by a small fault. (*Sere* is fermented fish paste, itself already odorous, but even more so when it is not fresh.) 'The fish that gets away is the big one' is the usual lament about the loss of a good opportunity while 'the big fish devours the little fish' needs no elaboration. In the Filipino Tagalog context, 'trying to get blood from a dried fish' refers to the rich squeezing the poor for everything, while the proverb 'a fish is caught by its mouth, a man by his words' cautions the control of one's tongue. 'The crab that instructed its young to walk straight' is a humorous crack at a non-exemplary character, while 'the shrimp knows not its own humped back' is an admonition for misplaced vanity.

Many other sayings are culled from the natural world. A boastful personality is likened to the hen which 'lays an egg and cackles all day through the village', in contrast to the turtle which 'lays a thousand without being seen or heard'. Characters who complement or match each other well are 'as like as two halves of a betel nut' (see Plate 11). In the Philippines, however, a 'peeled

betel nut' means some one who has gambled away or spent all he possessed.

The 'king of fruits', the durian, has its share of sayings, not all of which are complimentary. 'A durian showing its carpels' means a person revealing his true colours, while a character with many foul tricks up his sleeves is known simply as a 'durian'. However, the durian has some redeeming qualities, as may be seen in the saying 'the difference between a weak and a strong character is like the difference between the cucumber and the durian'.

To say that someone is like a dry *kepundung*—a small, unattractive, but delicious fruit—is to warn others not to judge him by his looks. Similarly, 'to plant a *cempedak* and to find a *nangka* growing up' warns parents not to predict how their children are going to turn out. Insincerity is described as 'planting sugar-cane on the lips' while hypocrisy is likened to 'the good look of the mango', whose smooth skin often belies its worm-eaten flesh.

Vegetables are also featured in various South-East Asian proverbs, though perhaps less frequently than rice or fruits. A sharp character is 'a Malacca chilli', the small *cili padi* described in Chapter 3, whose tiny size belies its powerful sting. The need to accept blame or acknowledge responsibility for one's actions is explained by the maxim 'it is the eater of chillies whose mouth feels hot', while the Burmese saying 'a real chilli, seven fathoms under water, will still taste hot' refers to someone or something that is genuine—the equivalent of the Chinese adage that real gold fears no fire. A 'sweet potato lawyer' is one who takes up bad cases for a small fee, while 'a bean that has forgotten its pod' means one who has forgotten his humble beginnings.

Indeed, the list of sayings related to food is inexhaustible. However, the examples above are more than sufficient to illustrate how fundamental the subject is to the cultures of South-East Asia. Not only does food figure prominently in the social, religious, and other important activities of the people of the region, but it has also found its way into the various languages.

Select Bibliography

Allen, Charles (ed.), *Tales from the South China Seas*, London, Andre Deutsch & BBC, 1983.

Barrett, J. Dean, 'Royal Revolutionaries of Siam', *Orientations*, Vol. 2, No. 5 (May 1971), 40.

Barrow, John, *A Voyage to Cochin China in the Years 1792 and 1793*, London, 1806; reprinted Kuala Lumpur, Oxford University Press, 1975.

Beekman, E. M., *The Poison Tree: Selected Writings of Rumphius on the Natural History of the Indies*, Amherst, University of Massachusettes Press, 1981; reprinted Kuala Lumpur, Oxford University Press, 1993.

Bird, Isabella L., *The Golden Chersonese and the Way Thither*, London, John Murray, 1883; reprinted Kuala Lumpur, Oxford University Press, 1967 and 1980.

Bock, Carl, *Temples and Elephants*, London, Sampson Low, Marston, Searle, and Rivington, 1884; reprinted Singapore, Oxford University Press, 1986.

Bowring, Sir John, *The Kingdom and People of Siam*, Vols. I and II, London, 1857; reprinted Kuala Lumpur, Oxford University Press, 1969.

Burleigh, Charles, *The Living Mekong*, Sydney, Angus & Robertson, 1971.

Burling, Robbins, *Hill Farms and Padi Fields: Life in Mainland Southeast Asia*, Phoenix, Arizona State University, 1992.

Burns, P. L. (ed.), *Papers on Malay Subjects*, Kuala Lumpur, Oxford University Press, 1971.

Cabotaje, Esther Manuel (ed.), *Food and Philippine Culture*, Manila, Centro Escolar University, 1976.

Campbell, Donald Maclaine, *Java Past and Present*, 2 vols., London, William Heinemann, 1915.

Charuruks, Irene Benggon and Padasian, Janette (eds.), *Cultures, Customs and Traditions of Sabah, Malaysia, An Introduction*, Kota Kinabalu, Sabah Tourism Promotion Corporation, 1992.

Chin, H. F. and Yong, H. S., *Malaysian Fruits in Colour*, Kuala Lumpur, Tropical Press, 1981.

Chou, Ta-kuan, *The Customs of Cambodia*, Bangkok, Siam Society, 1987.

Clyde, Stewart, 'The Bajau Cowboys', in *Straits Times Annual, 1960*, p. 76.

Copeland, Marks and Thein, Aung, *The Burmese Kitchen*, New York, M. Evans & Company, Inc., 1987.

Cordero-Fernando, Gilda (ed.), *The Culinary Culture of the Philippines*, Manila, Bancom Audiovision Corporation, 1976.

Cort, Mary L., *Siam: or The Heart of Further India*, New York, Anson D. F. Randolph & Co., 1886.

Davidson, Alan and Davidson, Jennifer (eds.), *Traditional Recipes of Laos*, London, Prospect Books, 1981.

De Wit, Augusta, *Java: Facts and Fancies*, The Hague, W. P. van Stockum, 1912; reprinted Singapore, Oxford University Press, 1984 and 1987.

Eiseman, Fred B., Jr., *Bali: Sekala and Niskala*, Vol. II, *Essays on Society, Tradition, and Craft*, Singapore, Periplus Editions, Inc., 1990.

Evans, Grant (ed.), *Asia's Cultural Mosaic: An Anthropological Introduction*, Singapore, Prentice Hall, Simon & Schuster (Asia) Pte. Ltd., 1993.

Fisher, Charles A., *South-east Asia: A Social, Economic and Political Geography*, London, Methuen & Co. Ltd., 1964; reprinted Bucks, Hazell Watson & Viney Ltd., 1971.

Gazzali, Dato Mohammed, 'Court Language and Etiquette of the Malays', in *Malaysian Branch of the Royal Asiatic Society: A Centenary Volume*, Vol. 72, Singapore, 1977.

Greenberg, Sheldon and Ortiz, Elisabeth Lambert, *The Book of Spices*, London, Michael Joseph Ltd., 1983; reprinted Singapore, Times Books International, 1984.

Gullick, J. M., *Malay Society in the Late Nineteenth Century: The Beginnings of Change*, Singapore, Oxford University Press, 1987; reprinted Singapore, Oxford University Press, 1989.

_____ (comp.), *They Came to Malaya: A Traveller's Anthology*, Singapore, Oxford University Press, 1993.

Hamilton, A. W. (trans.), *Malay Proverbs*, Singapore, Times Books International, 1987.

Hla Pe, *Burmese Proverbs*, London, John Murray, 1967.

Innes, Emily, *The Chersonese with the Gilding Off*, 2 vols., London, Richard Bentley & Son, 1885; reprinted in one vol., Kuala Lumpur, Oxford University Press, 1974.

Jaffrey, Madhur, *Far Eastern Cookery*, London, BBC Books, 1989.

Kelly, R. Talbot, *Burma: Painted and Described*, London, Adam & Charles Black, 1905.

Khin Myo Chit, *Colourful Burma*, 2 vols., Rangoon, Daw Tin Aye, 1988.

King, Clive (trans.), *Collins Guide to Tropical Plants*, London, Collins, 1983.

LeBar, Frank M. and Suddard, Adrienne, *Laos: Its People, Its Society, Its Culture*, New Haven, Hraf Press, 1960.

Loeb, Edwin M., *Sumatra: Its History and People*, n.p., Verlag des Institut, 1935; reprinted Kuala Lumpur, Oxford University Press, 1972 and Singapore, Oxford University Press, 1989.

Long, Rev. J., *Eastern Proverbs and Emblems*, London, Tubner & Co., 1881.

Ma, Huan, *Ying-yai Sheng-lan: The Overall Survey of the Ocean's Shores*, translated from the Chinese, edited by Feng Cheng-chun, Cambridge, Hakluyt Society at the University Press, 1970.

Madoc, Nancy, 'The Mem', in Charles Allen (ed.), *Tales from the South China Seas*, London, Andre Deutsch & BBC, 1983.

Manderson, Leonore (ed.), *Shared Wealth and Symbol: Food, Culture and Society in Oceania and Southeast Asia*, Cambridge, Cambridge University Press, 1986.

Marsden, William, *The History of Sumatra*, London, 1783; reprinted Kuala Lumpur, Oxford University Press, 1966 and Singapore, Oxford University Press, 1986.

Mohamed Ibrahim bin Abdullah, Munshi, *The Voyages of Mohamed Ibrahim Munshi*, translated by A. Sweeney and Nigel Phillips, Kuala Lumpur, Oxford University Press, 1975.

Morrison, Hedda, *Sarawak*, Singapore, Federal Publications (S) Pte. Ltd., 1976.

Pigafetta, Antonio, *First Voyage around the World*, Manila, Filipiniana Book Guild, 1969.

Ponder, Harriet W., *Javanese Panorama*, London, Seeley Service & Co. Ltd., 1942; reprinted as *Javanese Panorama: More Impressions of the 1930s*, Singapore, Oxford University Press, 1990.

Purseglove, J. W., *Tropical Crops: Monocotyledons*, London, Longman, 1972.

———, *Tropical Crops: Dicotyledons*, London, Longman, 1986.

Raffles, Thomas Stamford, *The History of Java*, London, 1817; reprinted Kuala Lumpur, Oxford University Press, 1965 and 1978, and Singapore, Oxford University Press, 1988.

Reid, Anthony, *Southeast Asia in the Age of Commerce, 1450–1680*, New Haven and London, Yale University Press, 1988.

Savage, Victor R., *Western Impressions of Nature and Landscape in Southeast Asia*, Singapore, National University of Singapore, 1984.

Scheltema, J. F., *Peeps at Many Lands: Java*, London, Adam & Charles Black, 1926.

Steinberg, Rafael, *Pacific and Southeast Asian Cooking*, New York, Time-Life Books, 1979.

Thompson, John Turnbull, *Some Glimpses into Life in the Far East*, London, Richardson & Co., 1864; reprinted as *Glimpses into Life in Malayan Lands*, Singapore, Oxford University Press, 1984.

Tooze, Ruth, *Cambodia: Land of Contrasts*, New York, Viking Press, 1962.

Tremblay, Helene, *Families of the World: Family Life at the Close of the 20th Century*, Vol. 2, *East Asia, Southeast Asia, and the Pacific*, New York, Farrar, Straus & Giroux, 1990.

Vincent, Frank, *The Land of the White Elephant: Sights and Scenes in South-East Asia, 1871–1872*, New York, Harper & Brothers, Publishers, 1874; reprinted Singapore, Oxford University Press in association with Siam Society, Bangkok, 1988.

Wallace, Alfred Russel, *The Malay Archipelago*, London, Macmillan & Company, 1869; reprinted Singapore, Oxford University Press, 1986.

Winstedt, Richard O., *Malay Proverbs*, London, John Murray, 1950; reprinted 1957.

Wood, Rebecca, *The Whole Foods Encyclopedia*, New York, Prentice Hall Press, 1988.

Young, Ernest, *The Kingdom of the Yellow Robe*, n.p., Archibald Constable & Co., 1898; reprinted Kuala Lumpur, Oxford University Press, 1982.

Zabilka, Gladys, *Customs and Culture of the Philippines*, Tokyo, Charles E. Tuttle Co., 1963.

Index

References in brackets refer to Plate numbers; those in brackets and italics to Colour Plate numbers.

Acar cili, 38, 51
Adobo, 17
Aniseed, 27
Arabs, 3, 4, 14, 25; proverbs, 73
Areca (*Areca catechu*), 36, 37, 38, (11);
 in proverbs, 75; *see also* Betel; *Sirih*
Arrack, 32
Asam, see Tamarind
Atap, 35; *atap* fruit, 36
Atchara, 51

Babi guling, 15
Bagoong, 12
Balachang, 11
Bali, Balinese, 3, 8, 15, 22, 31, 39, 71
Balut, 17
Bamboo: baskets, 61, 72; culms, 46,
 61; mats, 13, 68; shoots, 31, 45, 50,
 61; steamers, 66; straws, 44
Banana, 50, 52; flower, s*ee Bunga
jantung*; leaf as utensil, 10, 26, 34,
 46, 68
Banh trang, 13
Batu giling, 65
Batu lesung, 65
Bay leaf, 17
Bebenten, 8
Beef, 6, 8, 58; beef stew, 12; *see also*
 Buffalo
Belacan, 12, 14, 26–7, 48, 51, 61, 65;
 sambal belacan, 12, 46, 48
Belimbing, 17
Beras, 44, 46
Betel, 36; chew, 36, 38; quid, 8; nut,
 75, (11); *see also* Areca; *Sirih*

Bojo kromo, 9
Borneo, 3, 4, 8, 35, 54
Breadfruit, 54
Buah keras, see Candlenut
Brunei, 1, 3, 4, 9, 16, 68
Buddhism, 3, 8–9, 64, 73; offering
 food to the monks, 8–9, (*3*)
Buffalo, 6, 8, (*3*)
Bunga jantung, 50, (16d); *see also*
 Banana
Bunga kantan, 50
Burma, Burmese, 1, 3, 4, 10, 58, (17);
 food, 10–11, 13, 25, 40, 50, 58, 60,
 62, 64, 67; proverbs, 73

Ca cuong, 13
Cabai, cabi, 20
Calamansi, 26
Cambodia, 1, 3, 8, 9, 12, 46, 60
Candlenut, 24, 65, (7); *see also Buah
keras*
Capsaicin, 21
Capsicum, 20
Caraway seeds, 27
Cardamom, 38
Cempedak, 54; in proverbs, 76
Cekur manis, 50
Chilli, 11, 13–14, 33, 46, 47–8,
 50–1, 65, (*6*); in proverbs, 76;
 cili padi, 21
China, Chinese, 6, 12–14, 16–17, 21,
 27, 28, 29, 42, 44, 47– 8, 60, 67,
 71, 72; cleaver, 65; food, 10, 17, 22,
 27, 46; proverbs, 74, 76; spices, 10, 30
Chopsticks, 13, 34, 68, 71

81